ABANDONED BRITAIN

SIMON SUGDEN

AMBERLEY

First published 2022

Amberley Publishing
The Hill, Stroud
Gloucestershire, GL5 4EP

www.amberley-books.com

Copyright © Simon Sugden, 2022

The right of Simon Sugden to be identified as the Author of this work has been asserted in accordance with the Copyrights, Designs and Patents Act 1988.

ISBN 978 1 3981 1097 7 (print)
ISBN 978 1 3981 1098 4 (ebook)

British Library Cataloguing in Publication Data.
A catalogue record for this book is available from the British Library.

Typesetting by SJmagic DESIGN SERVICES, India.
Printed in the UK.

FOREWORD

I initially discovered Simon's work with the publication of his first book *Derelict Britain: Beauty in Decay* and I was so impressed with the images that I persuaded him to make a Zoom presentation for the Royal Photographic Society. It did not take long into our first conversation to realise the massive passion Simon has for his photographic subjects, and this has not diminished in the numerous discussions we have had since.

Certainly, photographers have had a fascination with architecture since the very dawn of photography. In 1827, Nicephore Niepce produced a heliograph *View from his Window at Las Gras*, in 1835 Henry Fox Talbot produced a calotype of *Lattice Window at Lacock* and in 1838 Louis Daguerre was producing views of the Boulevard du Temple in Paris. These early exponents of the art would have faced enormous difficulties in terms of the equipment they used in the fact it was very cumbersome and difficult to manoeuvre. Equally, the materials available to them were fragile and had very slow reaction time to light and often had to be rapidly developed soon after exposure. With the modern era Simon has not faced these difficulties; however, it is not all plain sailing, and he has dealt with his own set of complications in producing this volume.

These modern-day problems are also numerous, but I will mention just four. Firstly, the building owner often needs to be found and contacted to gain permission to photograph inside, which is invariably a time-consuming process. Secondly, the state of the building has to be assessed and health and safety aspects have to be considered. In this Simon's long experience in the building industry is of great assistance. Regrettably, some buildings are found to be just too dangerous to enter. Thirdly, although modern equipment is not as cumbersome in the same way as those facing the early exponents of the art, the interior conditions often require supplementary lighting be brought in to cast light into the often dark and boarded-up recesses of the building. Fourthly, the conditions in which the photography is carried out is often less than hospitable. Damp and dust are ubiquitous, and there are times when Simon is taking photographs standing up to his ankles in guano. These conditions often call for him to be kitted out with breathing apparatus and almost inevitably with protective clothing and hard hats before entering these vermin-infested, dusty, guano-soiled environments.

So, from this we can deduce his last exhibition in November 2021 was very aptly named 'Textile Mills and Derelict Thrills', which continued the wonderful tradition he set up with his first exhibition, 'The Beauty in Decay', held at Cliffe Castle Museum in Keighley during the summer of 2019. There, as in this book, we get to view a treasure trove of evocative buildings – derelict, abandoned and, in many cases, close to obliteration by demolition, redevelopment or plain decrepitude. Some – very few, probably – have still retained a degree of public affection, but their neglect rejects any notion of them being badged as a cherished cultural artefact. For many of these buildings Simon has to coin Cartier Bresson's famous saying that he caught the 'decisive moment' before their demise.

I am sure many of the buildings appear dismal and disintegrating at first sight, but they are transformed under Simon's lens to be evocative and atmospheric, prompting our imaginations and often imparting a sense of sadness. This is no more so than when he includes some relic of human occupation in his compositions, with a jarring emotional impact. At other times an inherent beauty is revealed by his 'seeing eye', where natural light has fought its way in to evocatively illuminate the interior or he has skilfully arranged artificial lighting to reveal some hidden detail. Whether mundane and functional or decorative, ornate and faded, Simon has achieved aesthetically pleasing images throughout.

Today pictures are everywhere, whether the product of mobile phones or produced by cameras. We are worn down by pictures that are ok, but mundane, ordinary, commonplace – in a word, boring. So, it is a great pleasure to find a book like this where there is excitement in turning every page and a personal eagerness to find what comes next, whether it be an old mill, an abandoned cottage or factory. There is quality in the images, in the composition and in the use of light. Equally, this is an historical documentation of buildings that are facing if not total destruction, then irrevocable changes. Some sadly have already disappeared.

So, in conclusion, I must congratulate both Simon and his publisher for producing this book. Its great value is how it so ably captures for posterity these buildings at one moment in time, that fraction of a second when the camera shutter opened and closed. In short, Simon has given these buildings a new life in this book, preserving a tangible visual record for present and future generations.

Tim Sanders BA (Hons), BSc (Hons), LRPS
Regional Organiser, South West Region, of the Royal Photographic Society

ACKNOWLEDGEMENTS

Grateful thanks go to the people who have helped me on my photographic journey: photographers Karl Mann, Ian Bale, James Brightwell and Bernard Todd; my close friends Phil Clayton, Andrew Passmore, Lewis Hacket; and my family, including my daughter Jennie, who have given me such great support over the years.

ABOUT THE AUTHOR

Simon Sugden was born in Ilkley and has been interested in photography for most of his life. He picked up his first DSLR fourteen years ago when he bought a cheap camera from a friend and is self-taught. Simon loves most aspects of photography, but his main passion is architecture, which led him to start taking images of abandoned buildings. He works freelance for a building company and Bradford Council, which has been helpful in photographing the interior of buildings normally closed to the general public and for whom he has been documenting the Darley Street Market project. Simon has received a couple of awards, including one from the National Science and Media Museum in Bradford in the Drawn by Light competition for his photograph *Lighting Up the Yard* (Crossley Evans Scrapyard). He is proud to be documenting these amazing places for the next generation, including his daughter Jennie, who is now five and already picking up a camera.

This pushed Simon to study photography further, and his images have featured in magazines and newspapers and also on album covers. An opportunity came up for an exhibition at the Cliffe Castle Museum, Keighley, where his work was shown under the title 'The Beauty in Decay' for three months from July until September 2019. This was followed by another exhibition in November 2020 entitled 'Textile Mills and Derelict Thrills'. Positive feedback from the exhibitions has helped Simon's images to reach the public via social media, newspapers and this book. This is his second book for Amberley Publishing, following *Derelict Britain: Beauty in Decay*, which was published in 2020.

Copies of Simon's photographs are available to order from his website, suggysphotography.uk, or from Suggys Photography on Facebook (facebook.com/suggyspics).

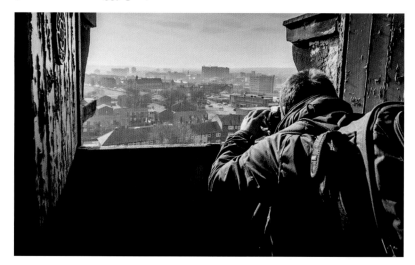

The author on location. (Courtesy of Martin Beaumont)

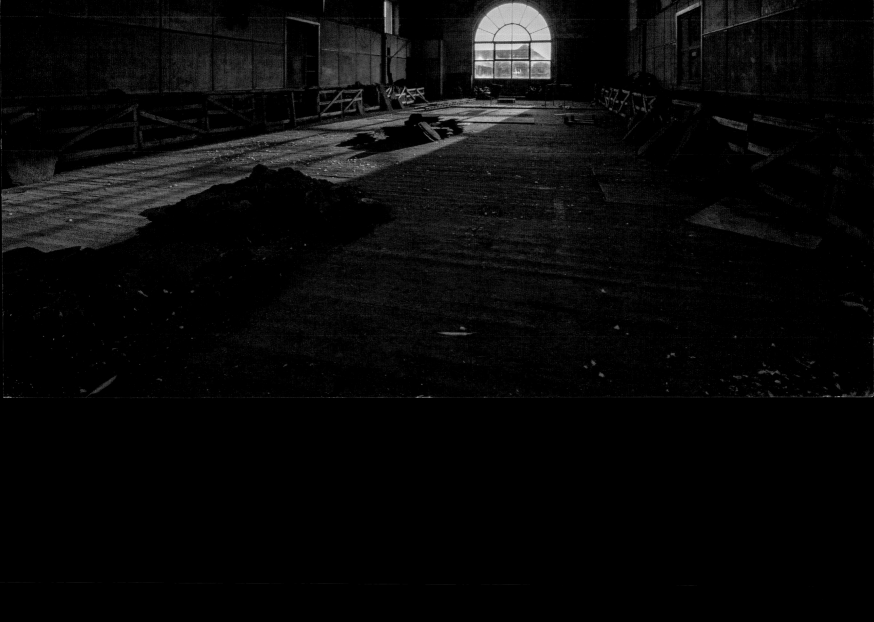

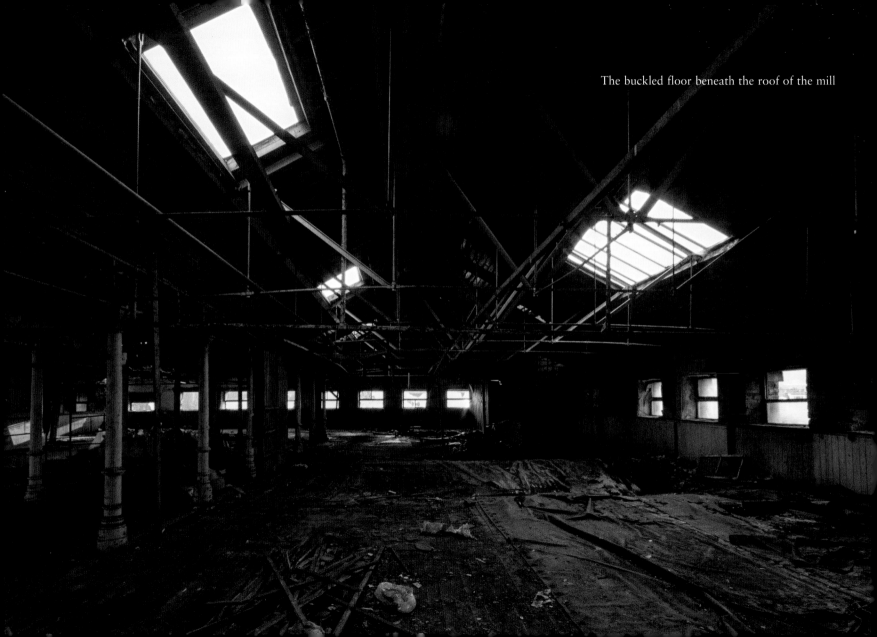

The buckled floor beneath the roof of the mill

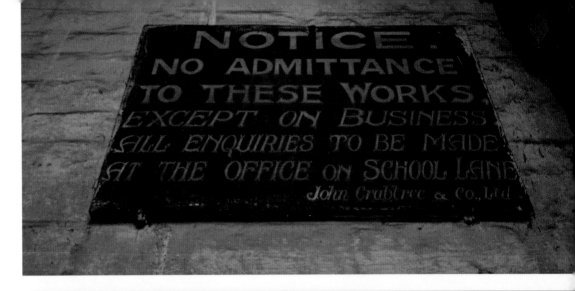

No admittance to these works except on business

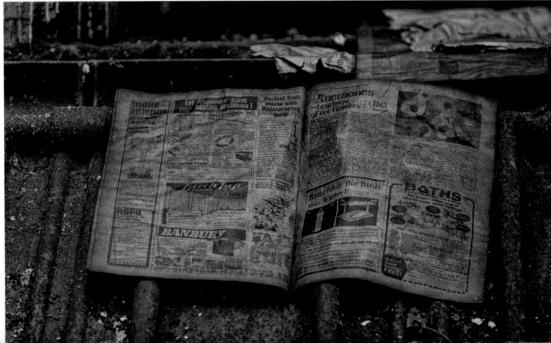

I found this old gardening magazine on the
floor of the mill

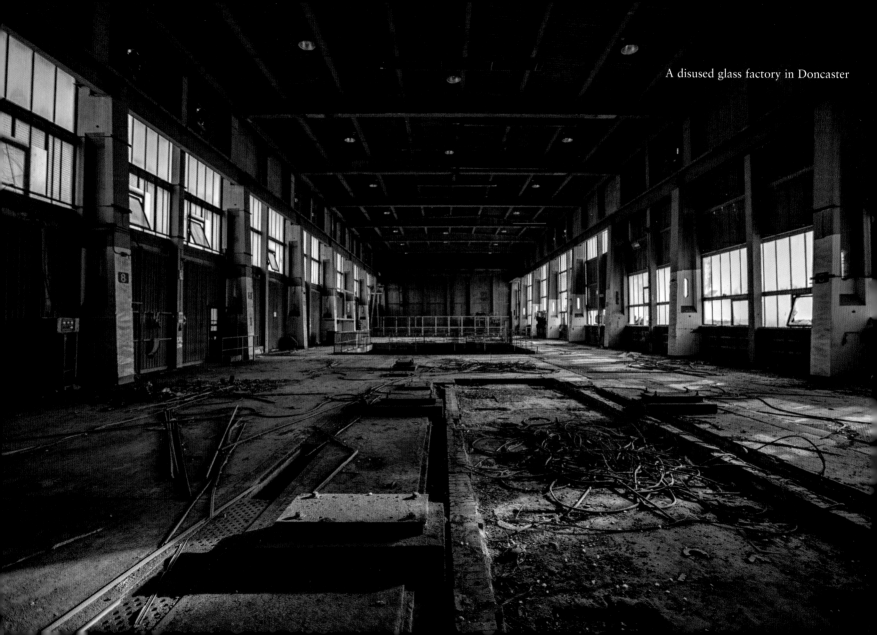

A disused glass factory in Doncaster

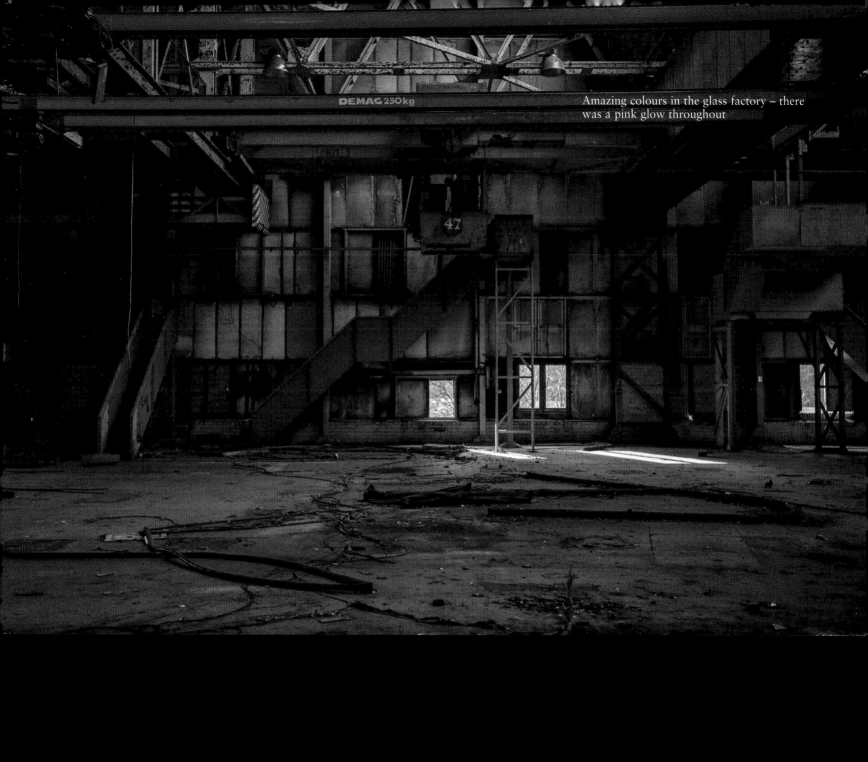

Amazing colours in the glass factory – there
was a pink glow throughout

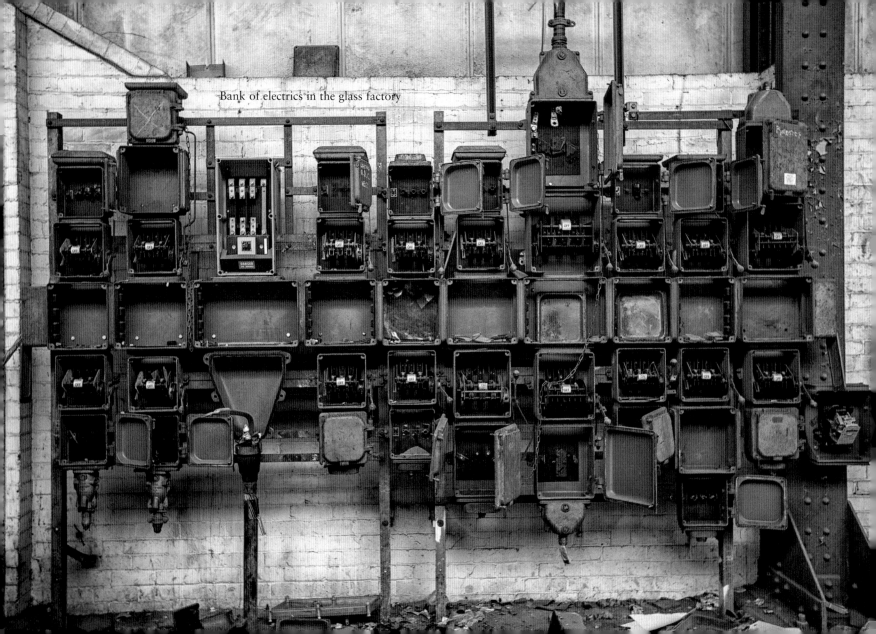

Bank of electrics in the glass factory

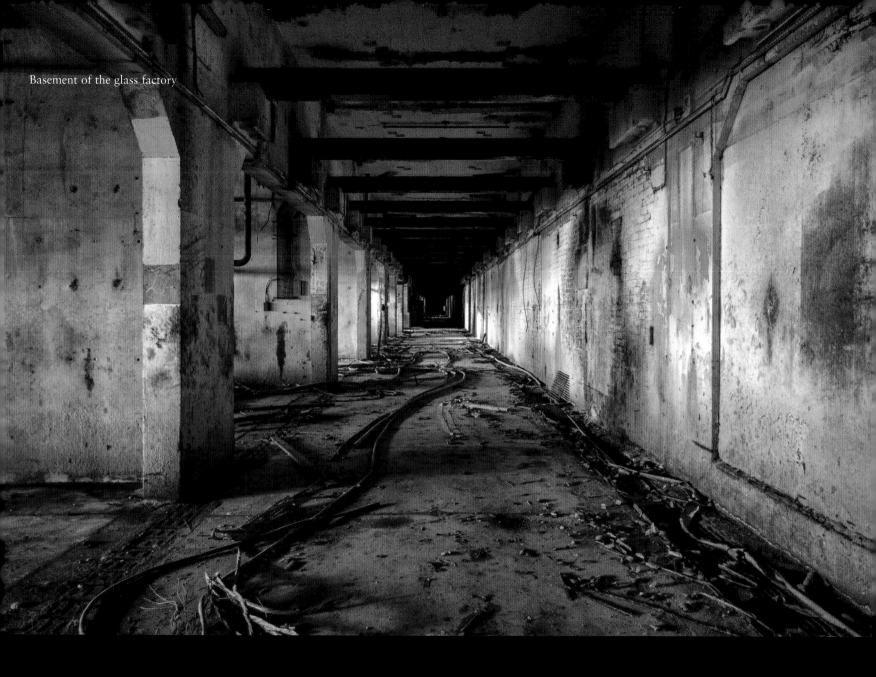

Basement of the glass factory

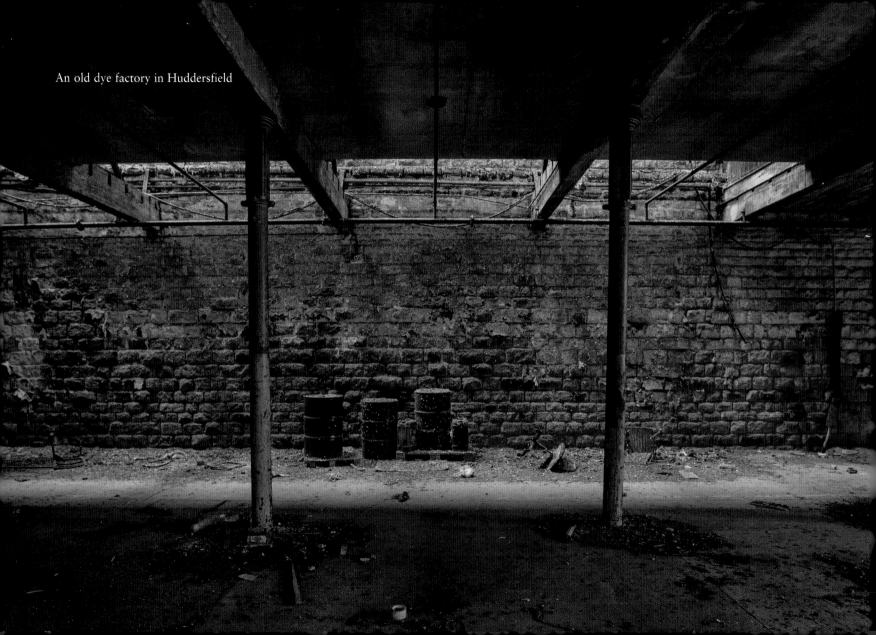

An old dye factory in Huddersfield

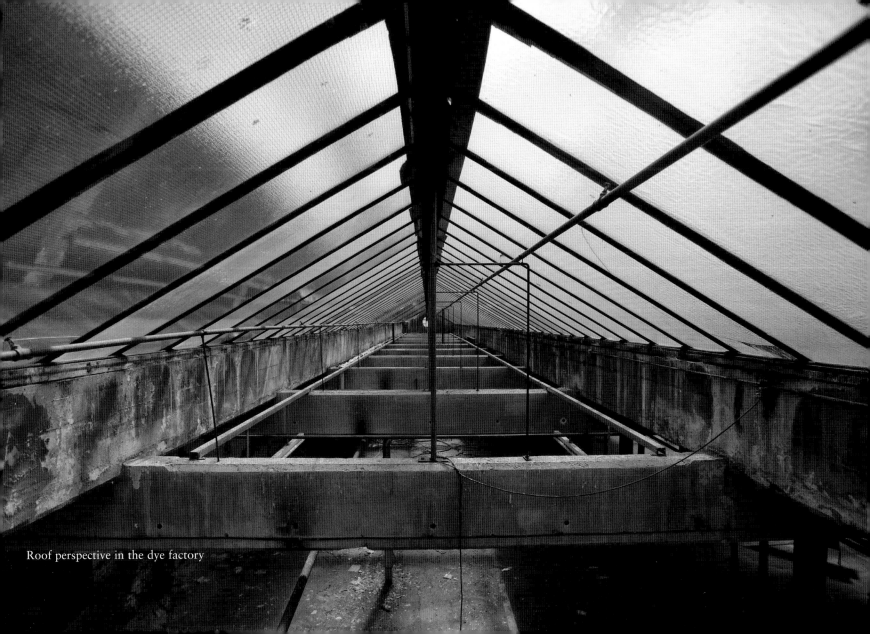

Roof perspective in the dye factory

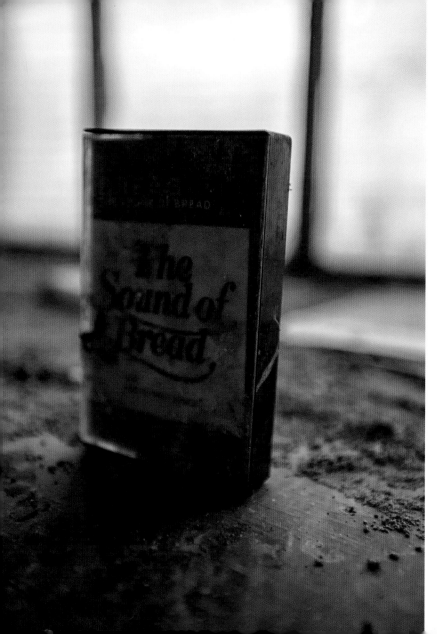

Left: The Sound of Bread!

Below: Empty fire hose reel in Halifax

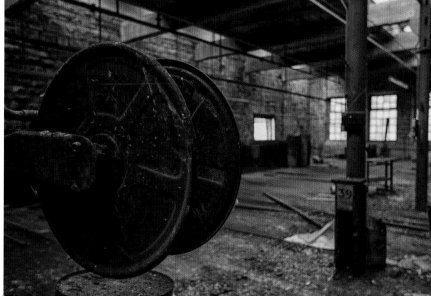

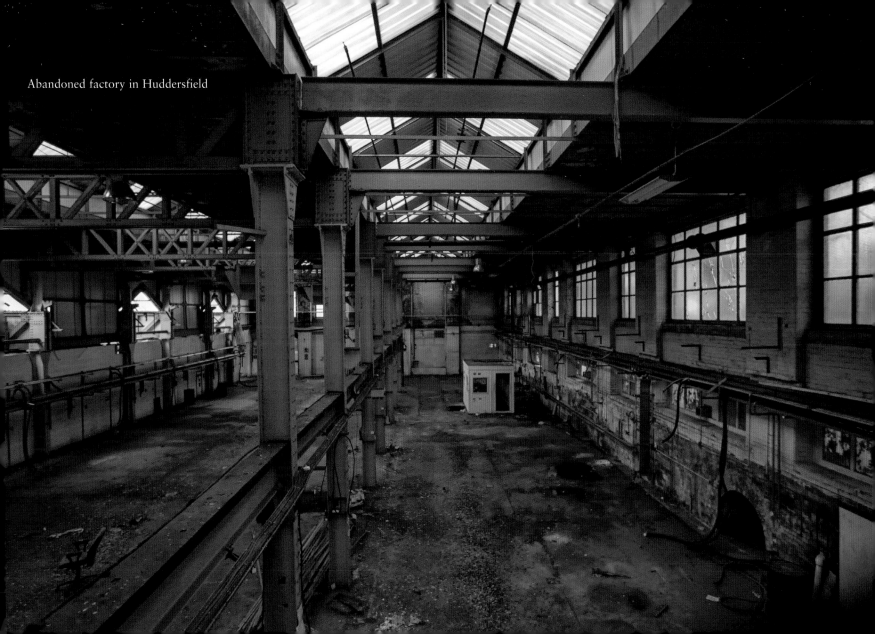

Abandoned factory in Huddersfield

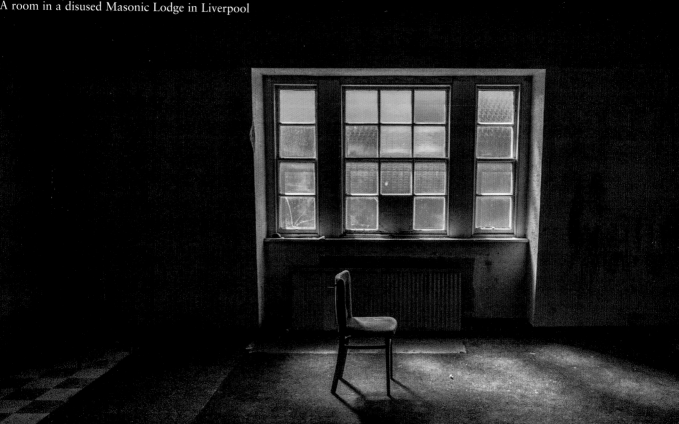

A room in a disused Masonic Lodge in Liverpool

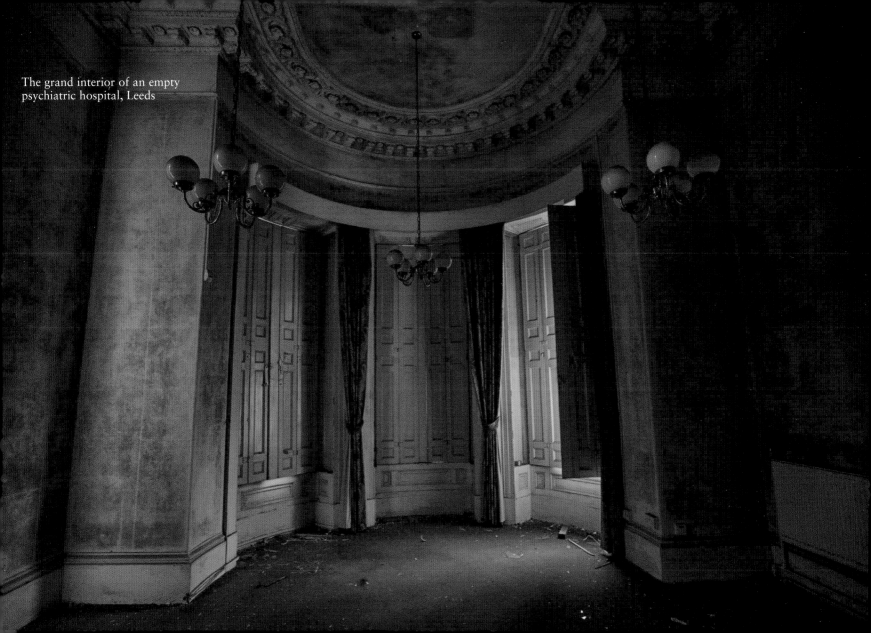

The grand interior of an empty
psychiatric hospital, Leeds

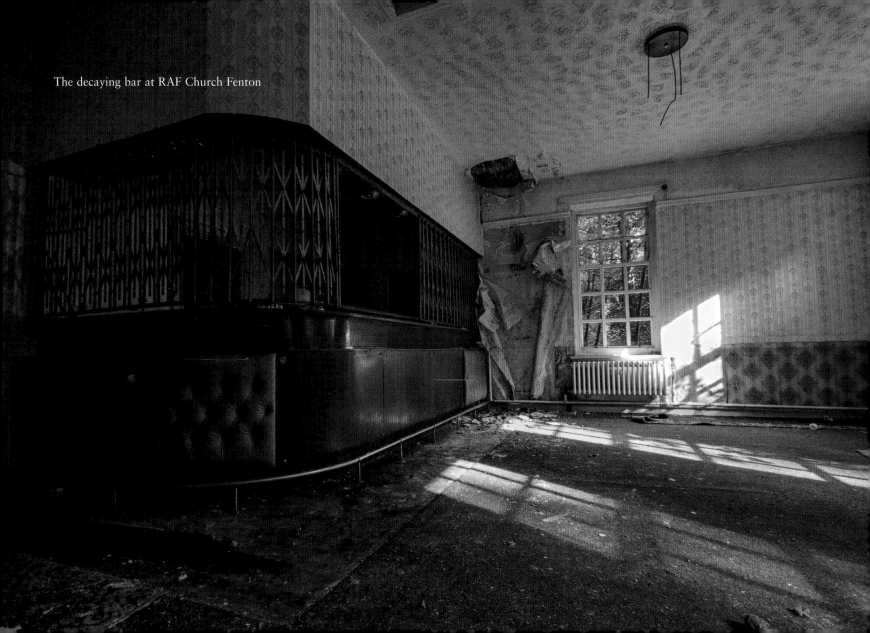
The decaying bar at RAF Church Fenton

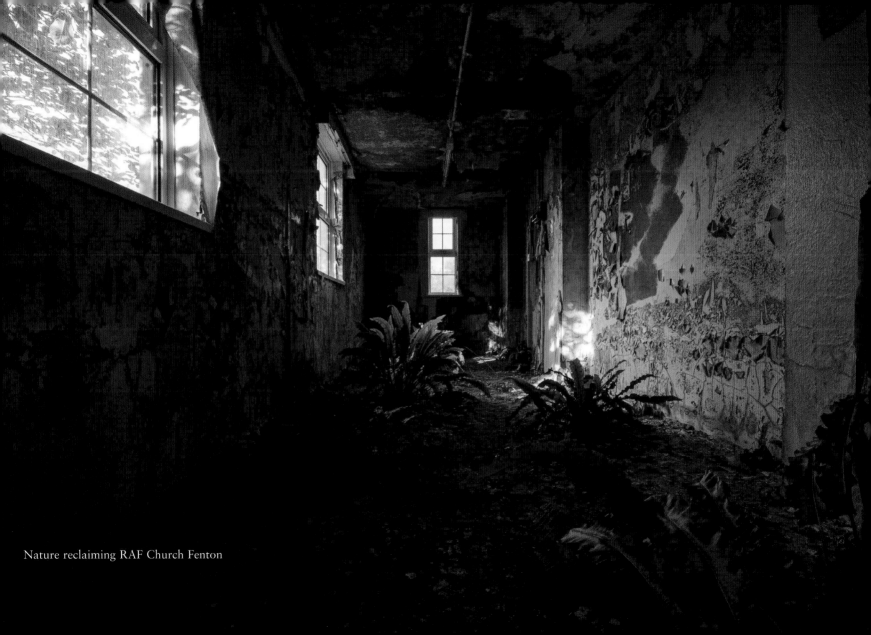

Nature reclaiming RAF Church Fenton

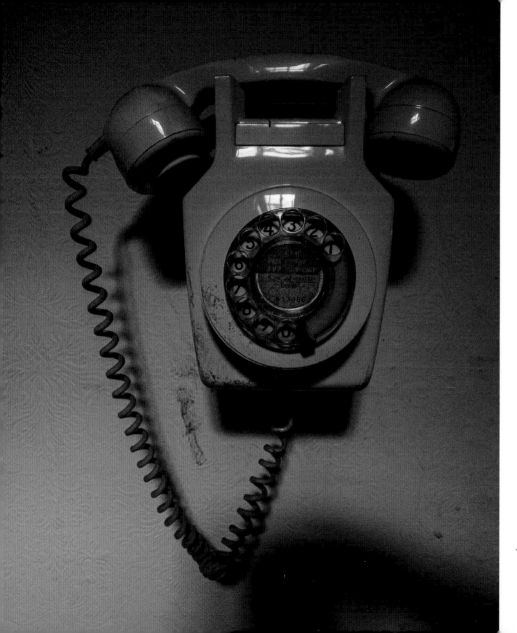

Telephone on the wall of an old farmhouse in West Yorkshire

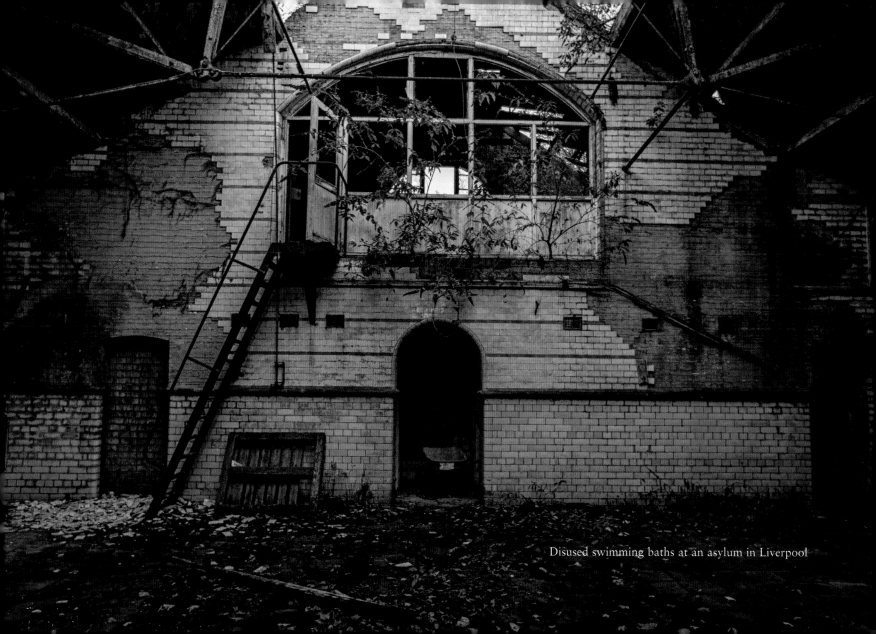

Disused swimming baths at an asylum in Liverpool

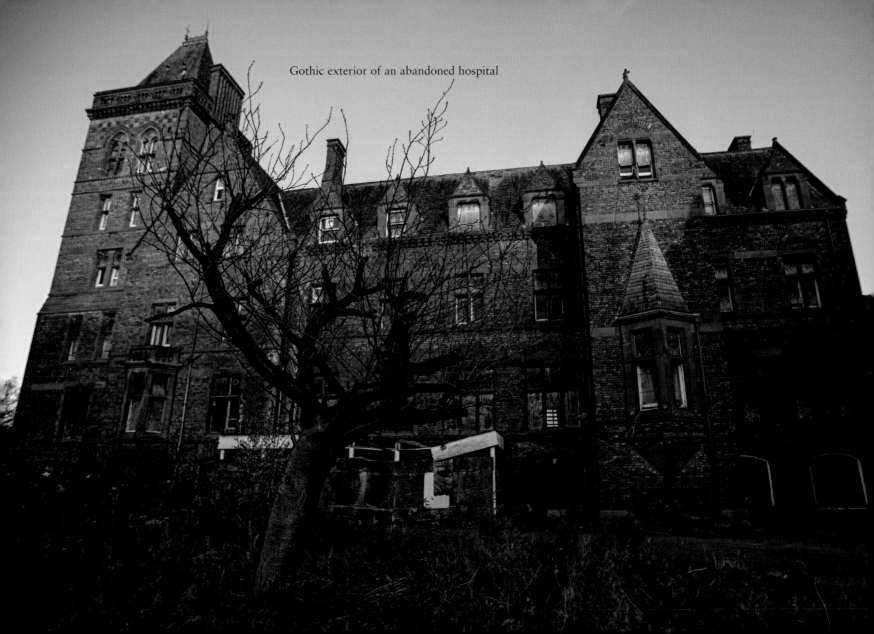
Gothic exterior of an abandoned hospital

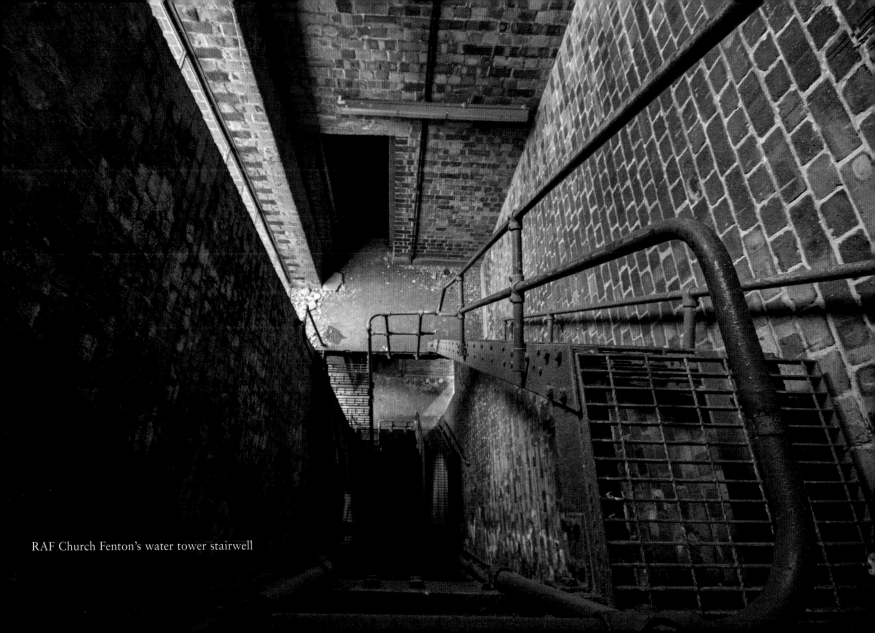

RAF Church Fenton's water tower stairwell

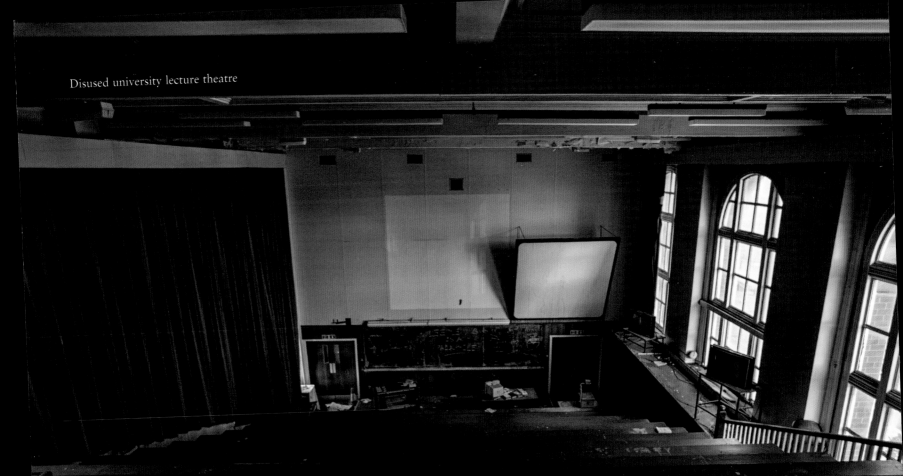

Disused university lecture theatre

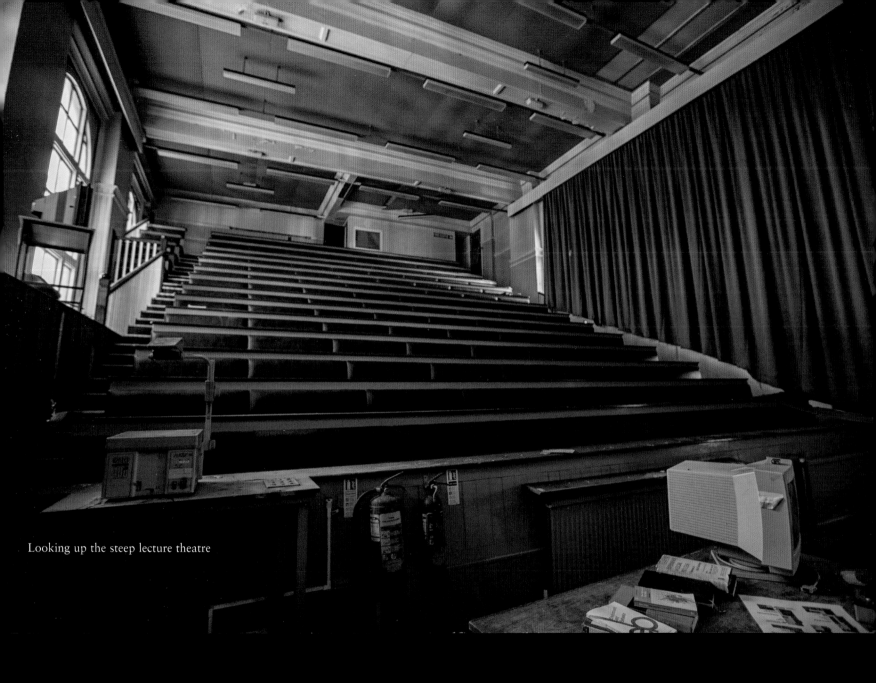

Looking up the steep lecture theatre

British butterfly identification chart on the
wall of the lecture theatre

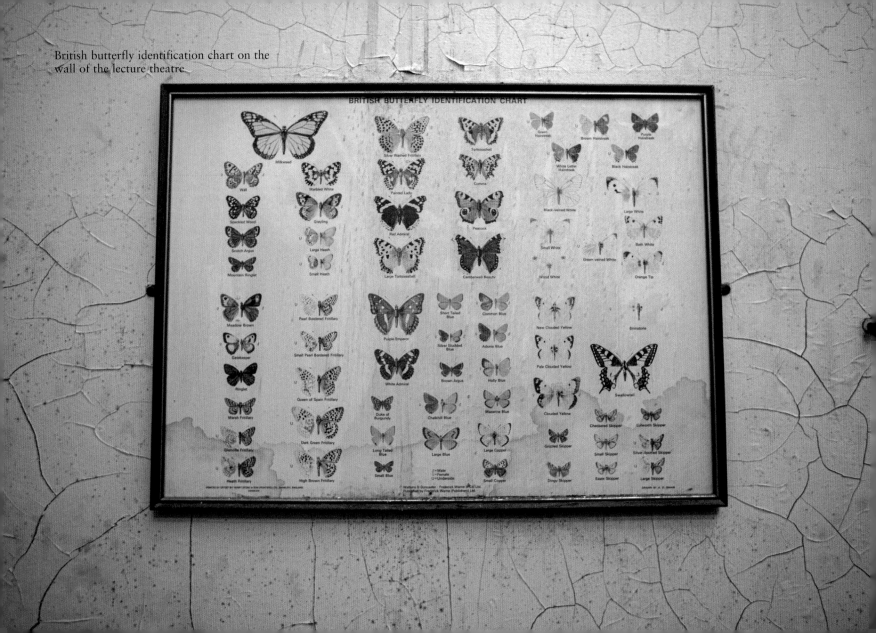

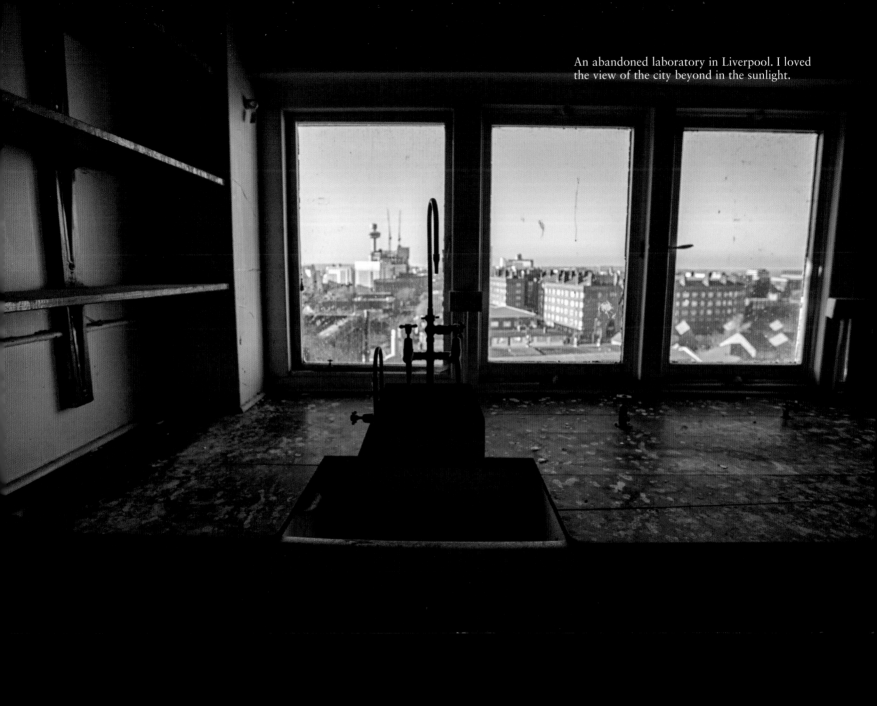

An abandoned laboratory in Liverpool. I loved the view of the city beyond in the sunlight.

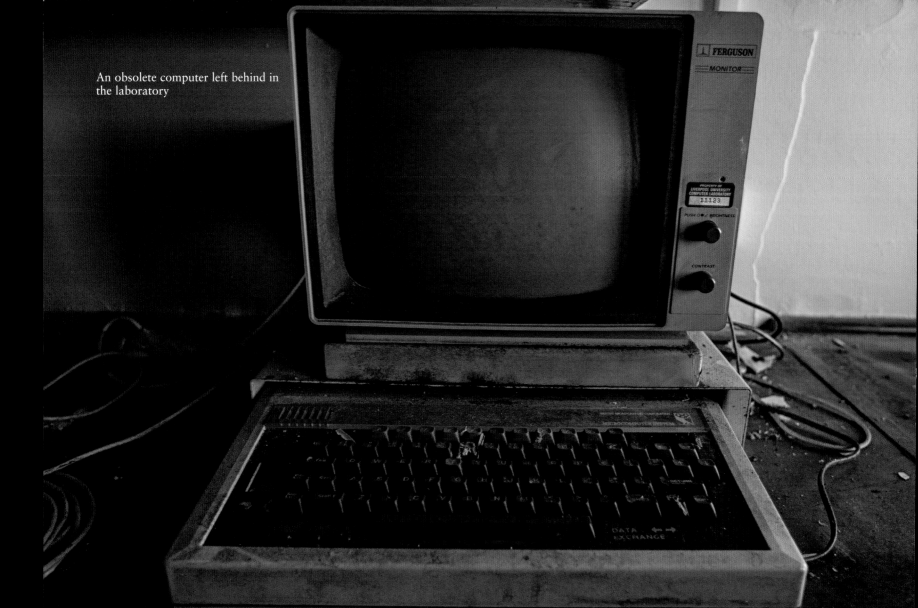

An obsolete computer left behind in the laboratory

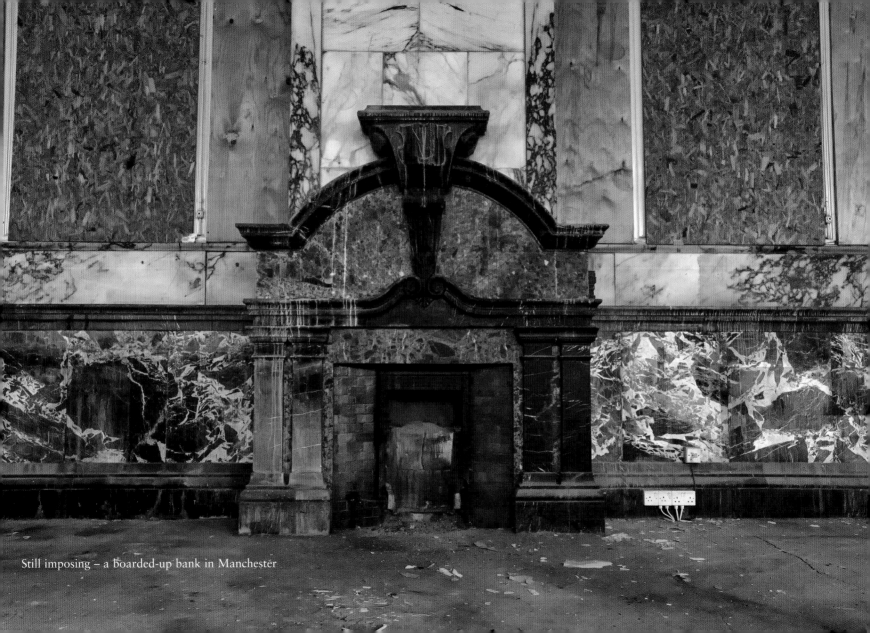

Still imposing – a boarded-up bank in Manchester

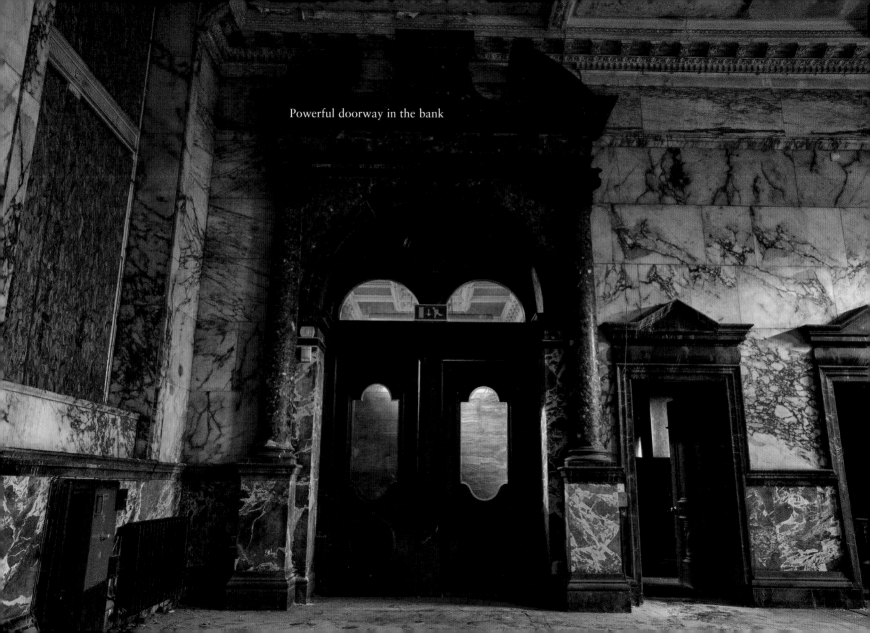

Powerful doorway in the bank

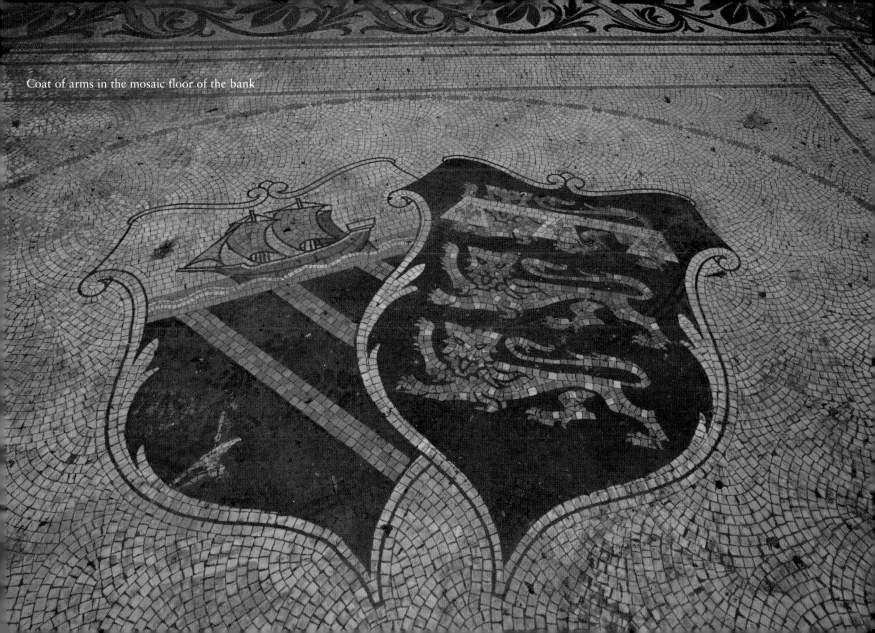

Coat of arms in the mosaic floor of the bank

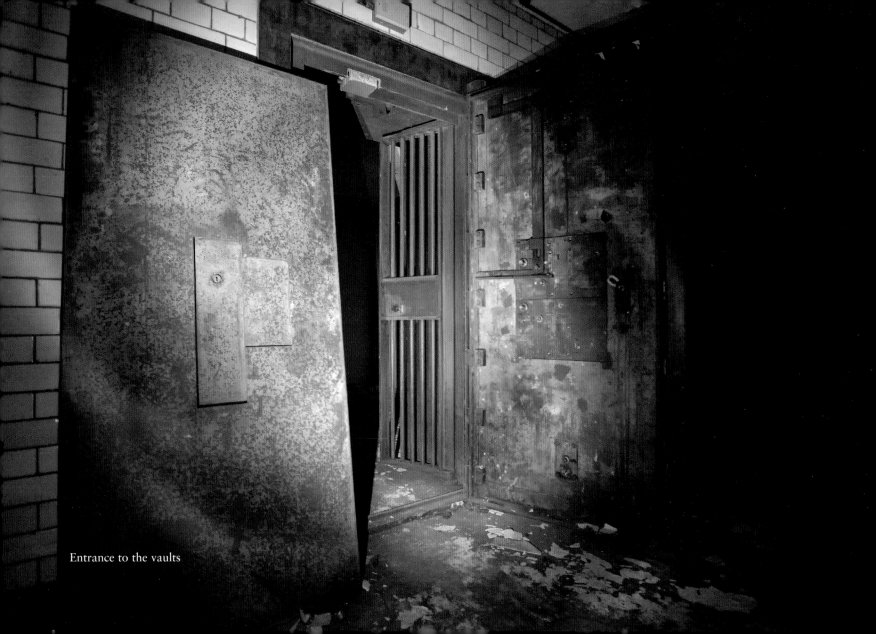

Entrance to the vaults

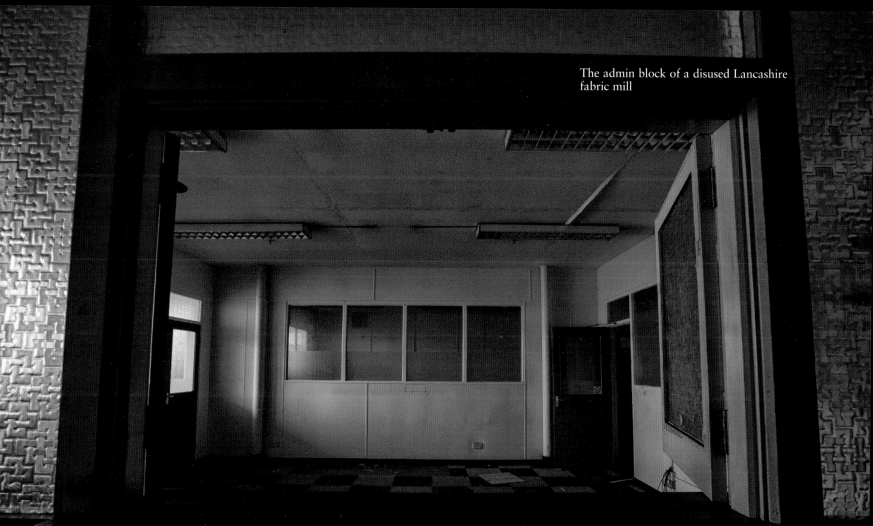

The admin block of a disused Lancashire fabric mill

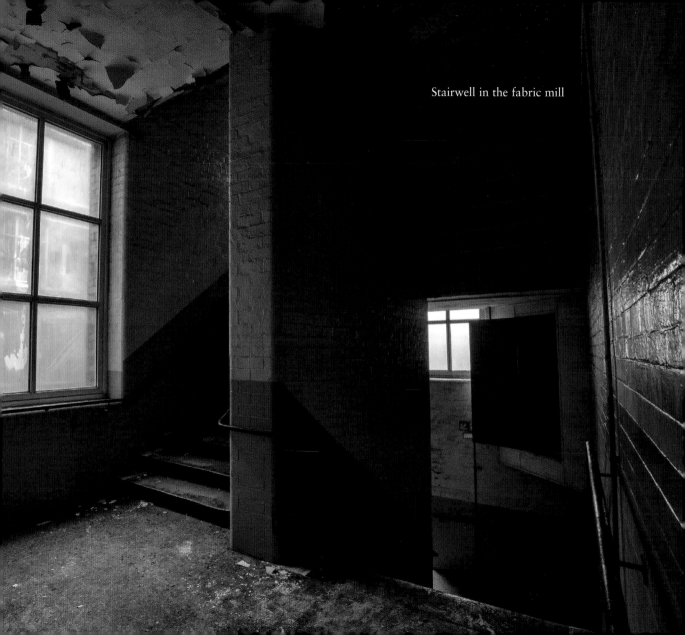

Stairwell in the fabric mill

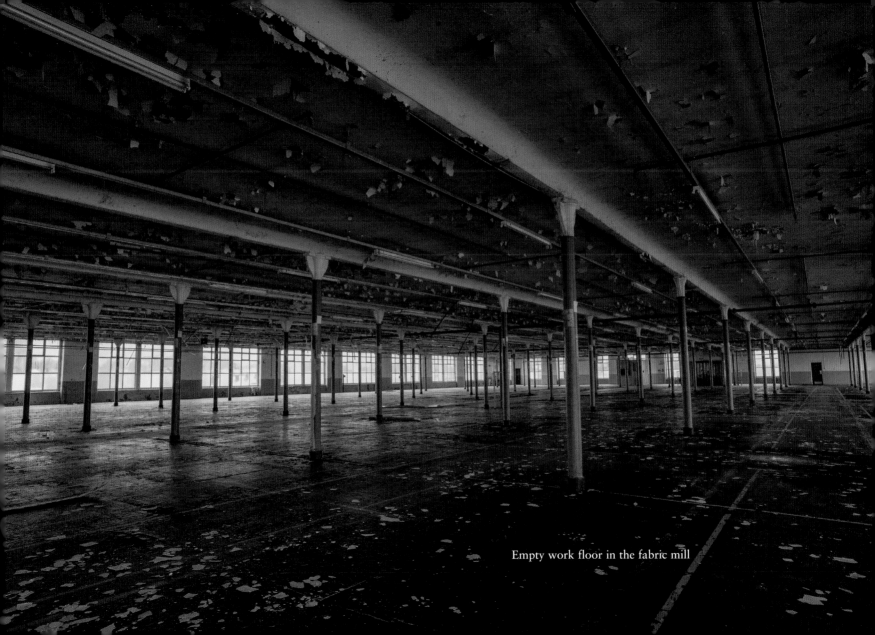

Empty work floor in the fabric mill

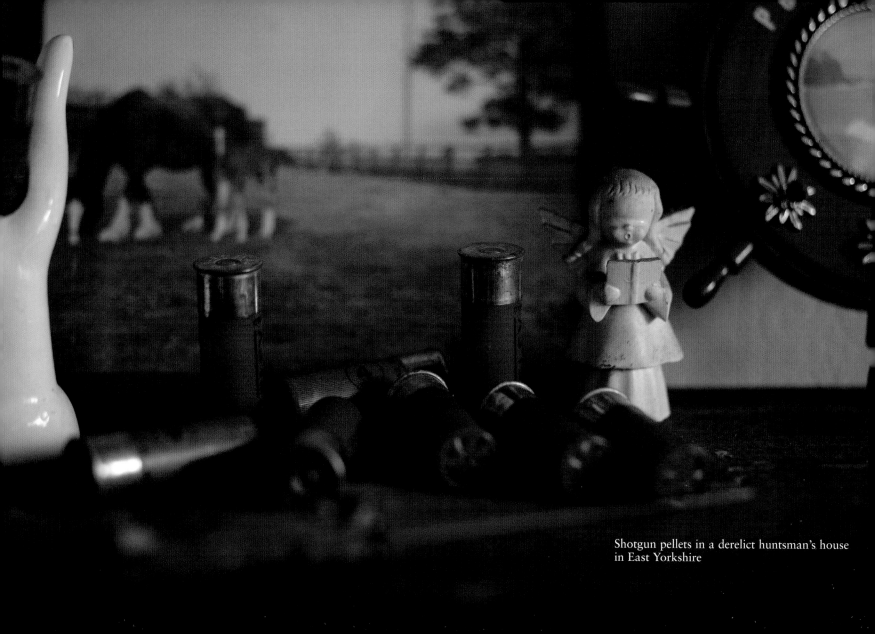

Shotgun pellets in a derelict huntsman's house
in East Yorkshire

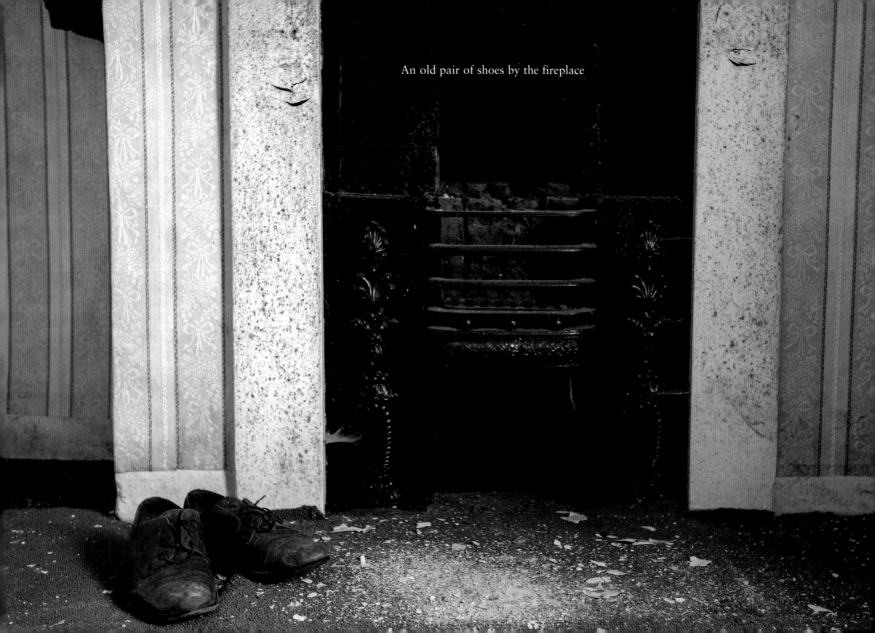

An old pair of shoes by the fireplace

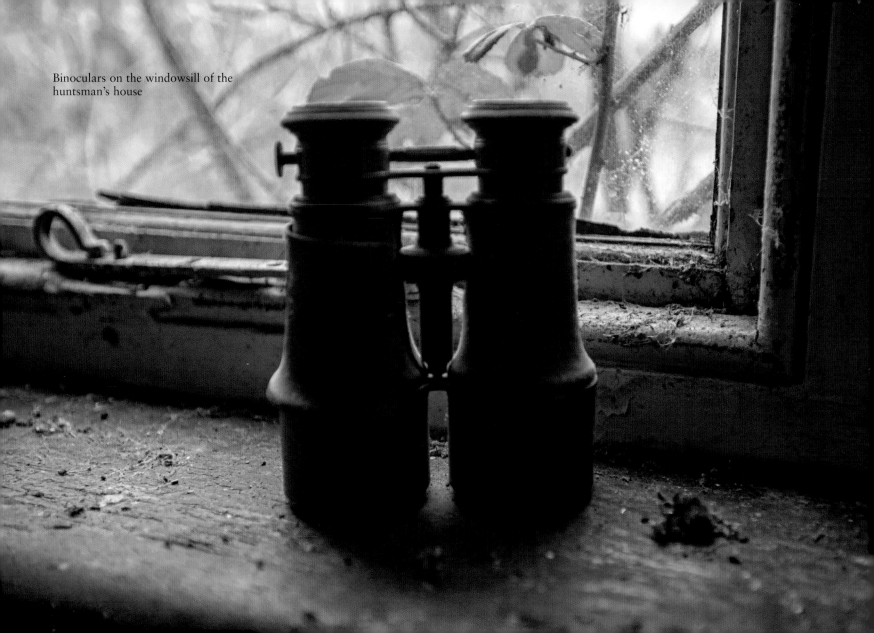

Binoculars on the windowsill of the huntsman's house

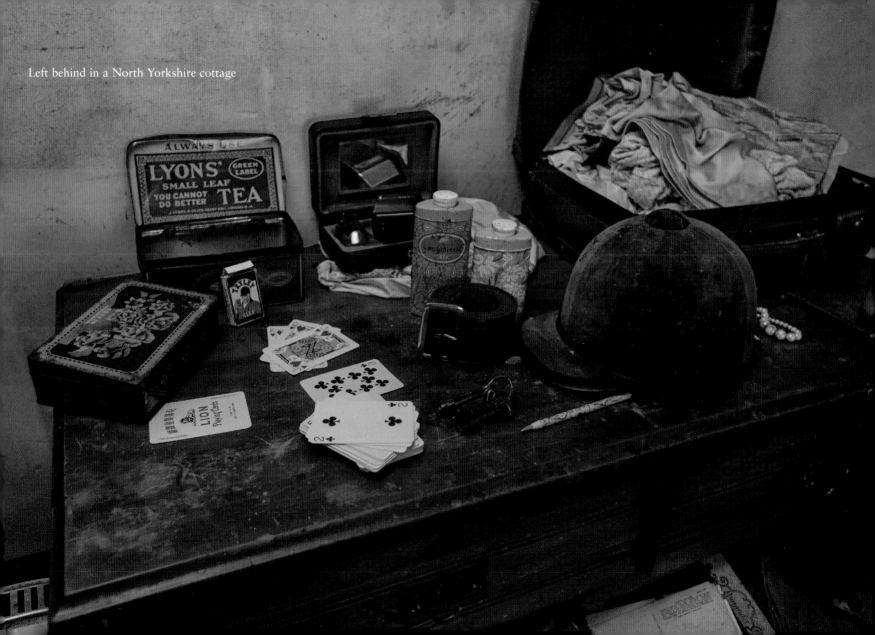

Left behind in a North Yorkshire cottage

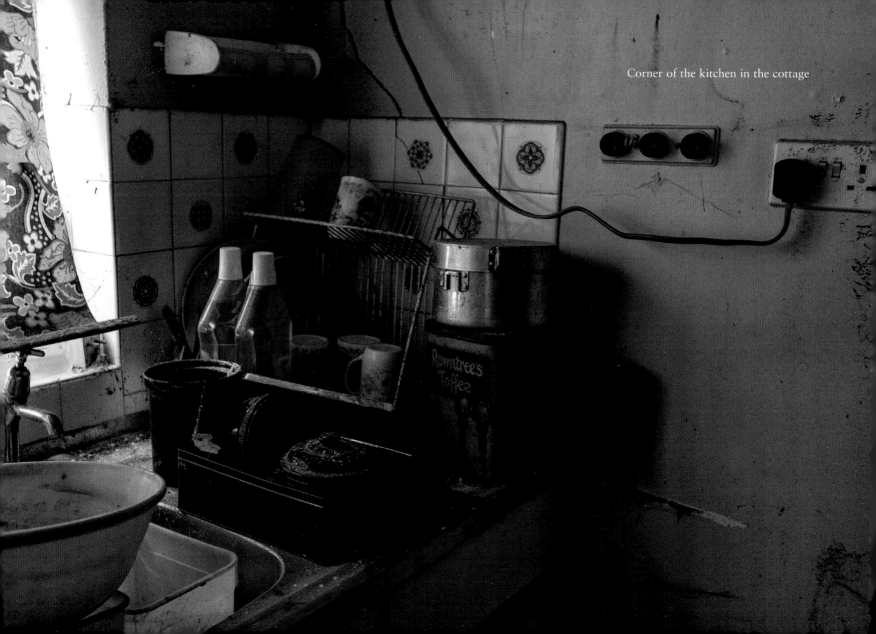

Corner of the kitchen in the cottage

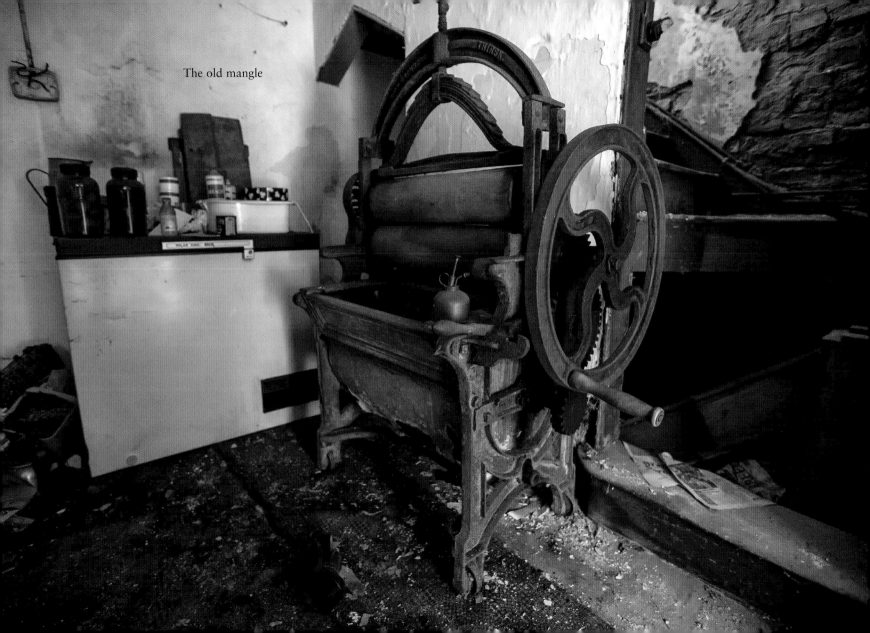

The old mangle

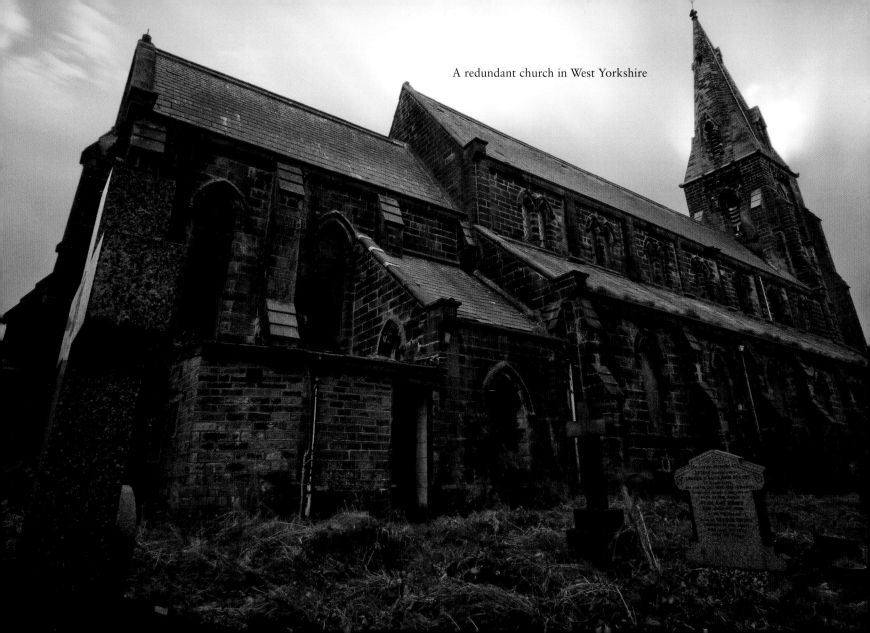

A redundant church in West Yorkshire

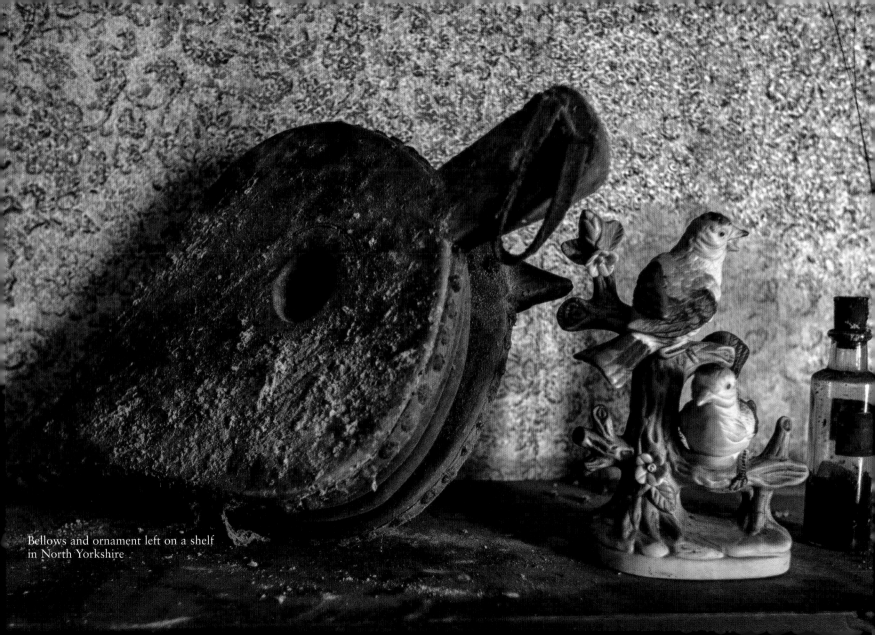

Bellows and ornament left on a shelf
in North Yorkshire

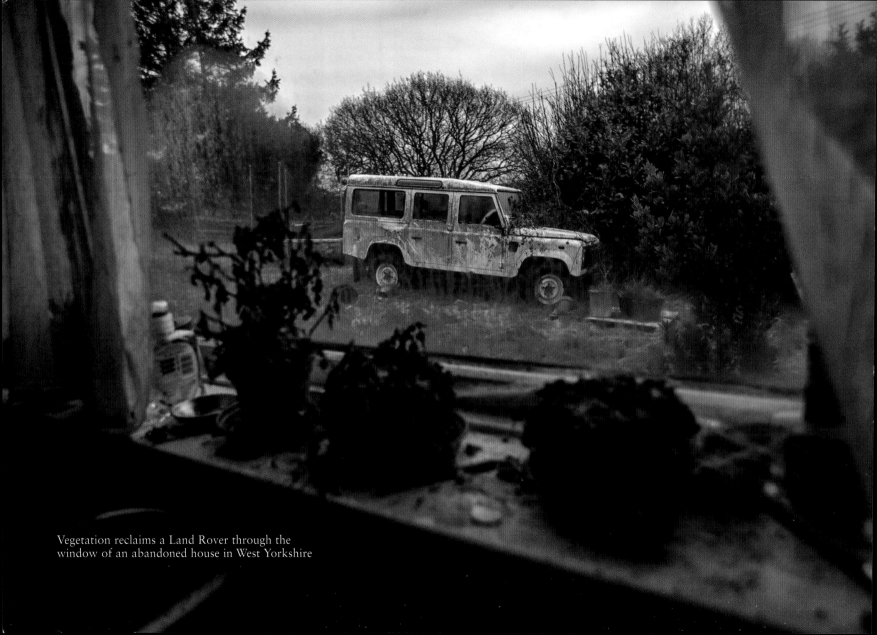

Vegetation reclaims a Land Rover through the
window of an abandoned house in West Yorkshire

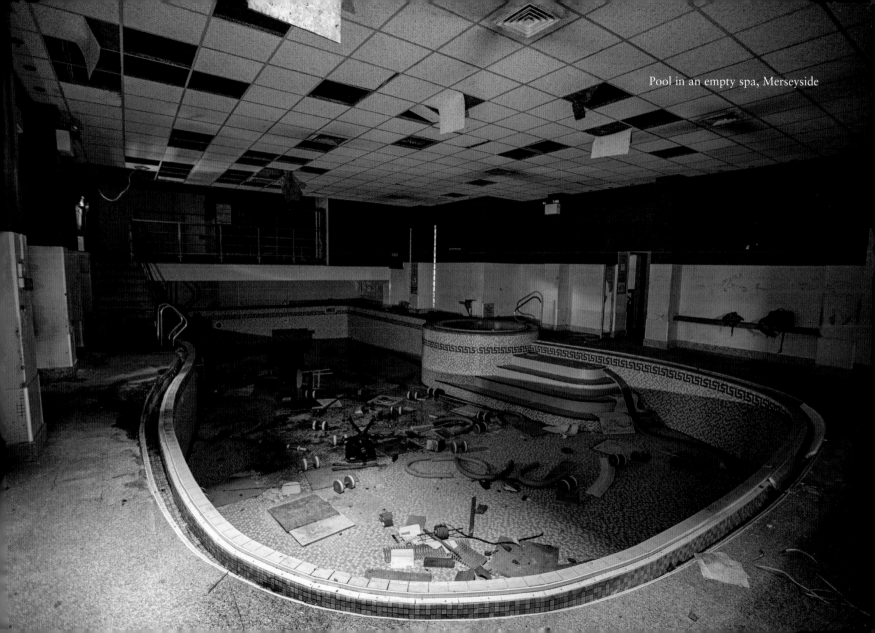

Pool in an empty spa, Merseyside

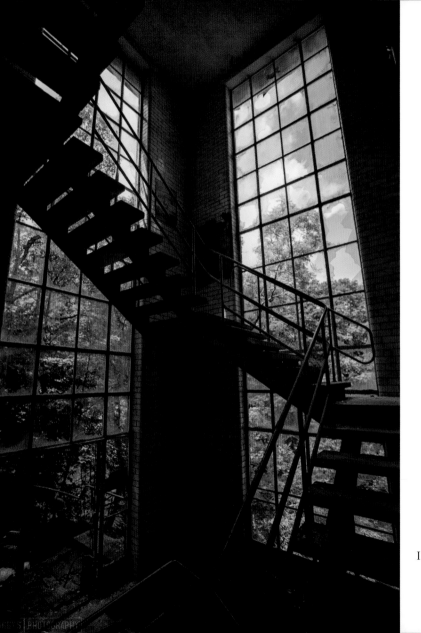

I love the large windows by the staff staircase in this Yorkshire mill

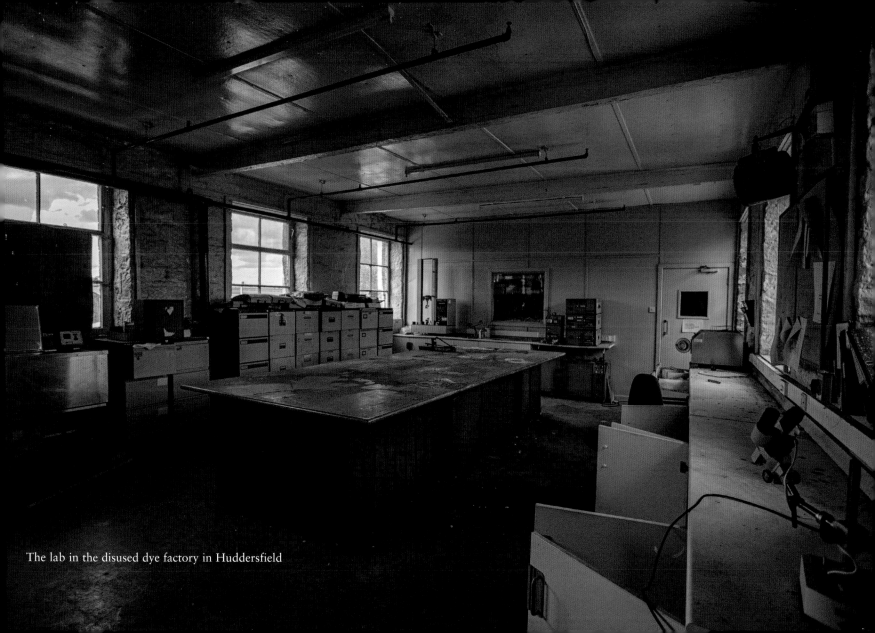

The lab in the disused dye factory in Huddersfield

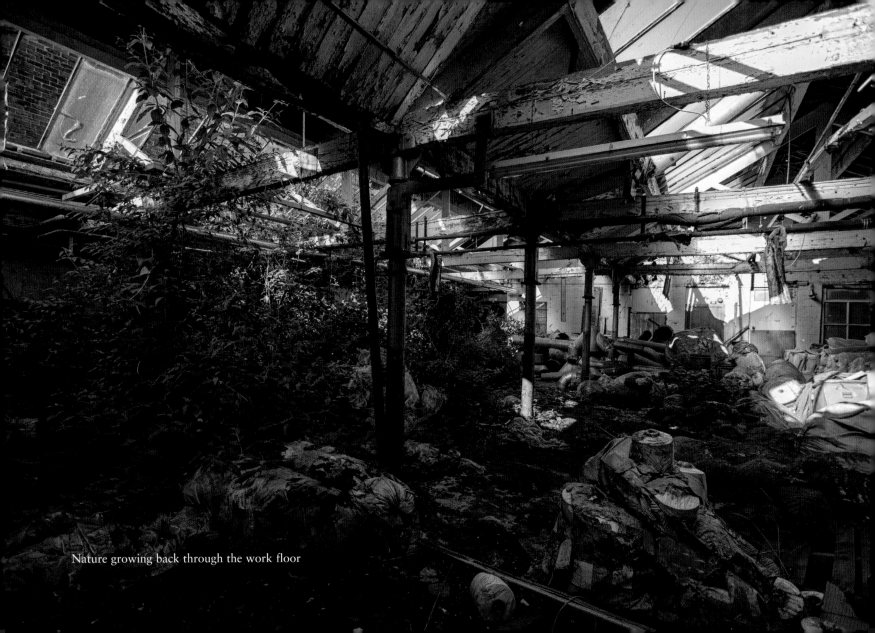

Nature growing back through the work floor

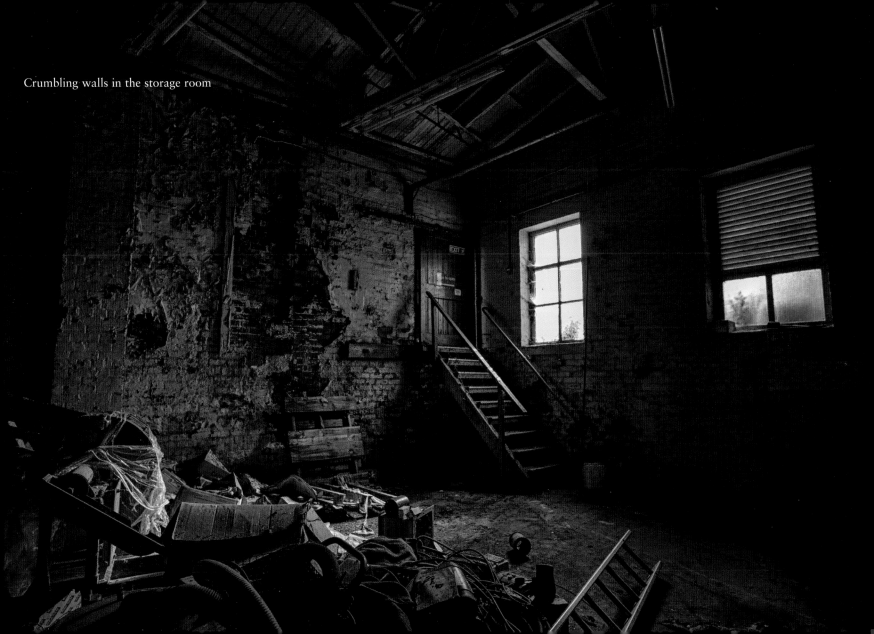

Crumbling walls in the storage room

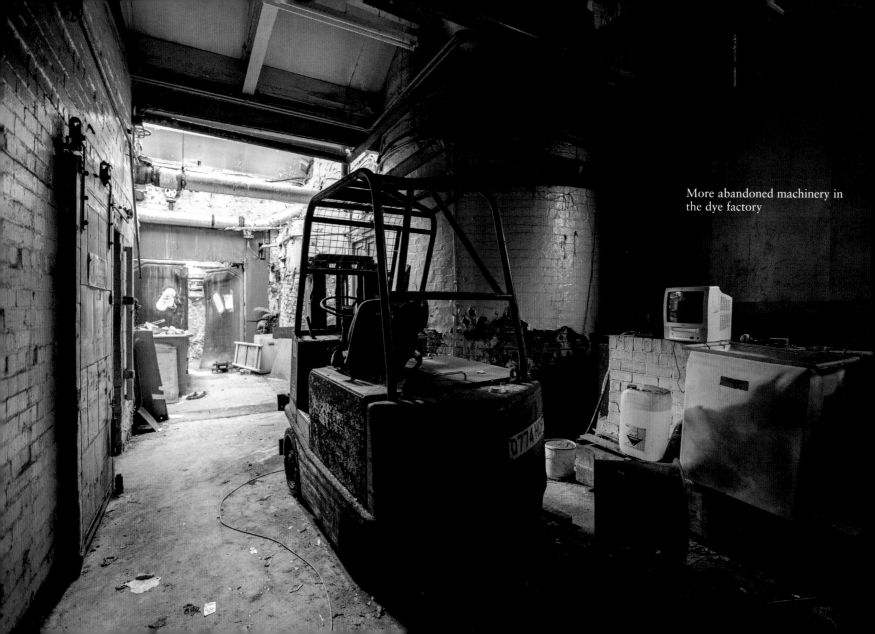

More abandoned machinery in
the dye factory

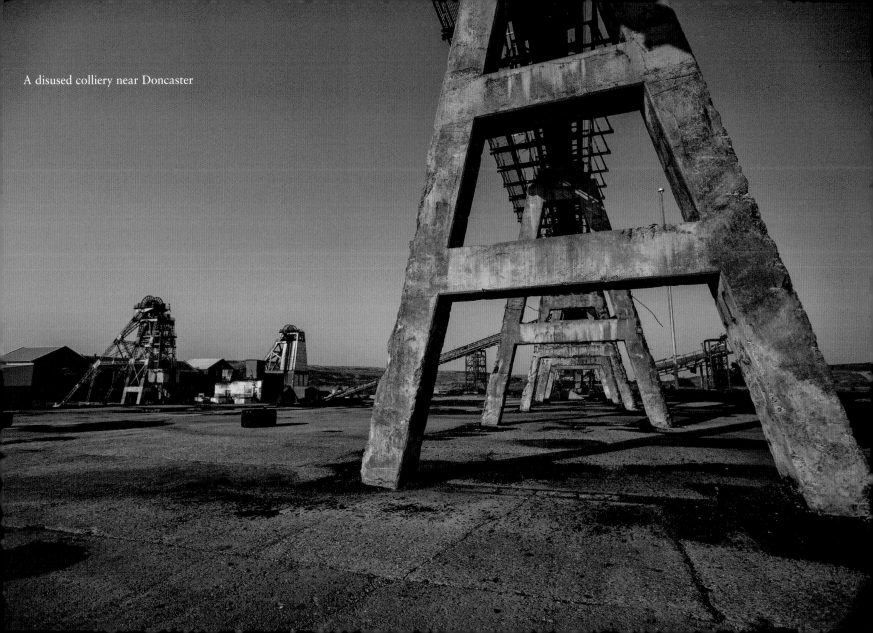

A disused colliery near Doncaster

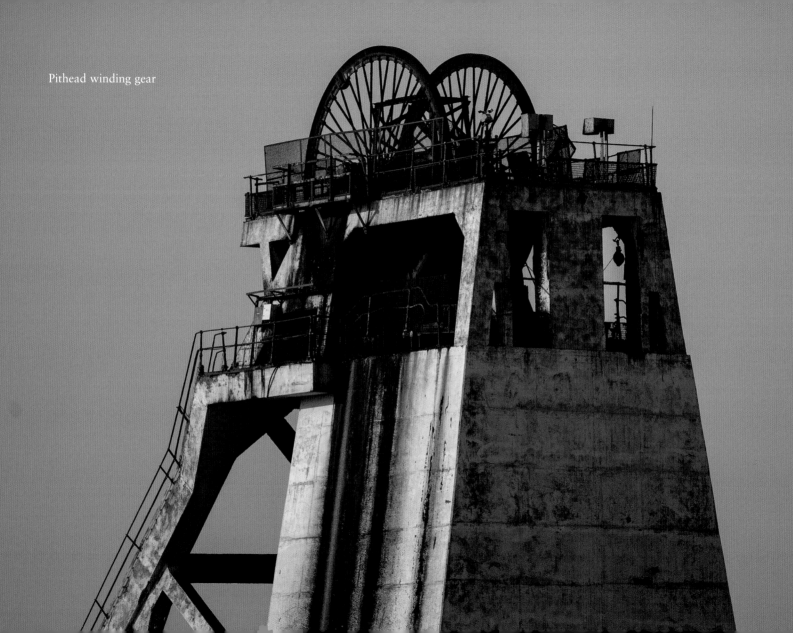

Pithead winding gear

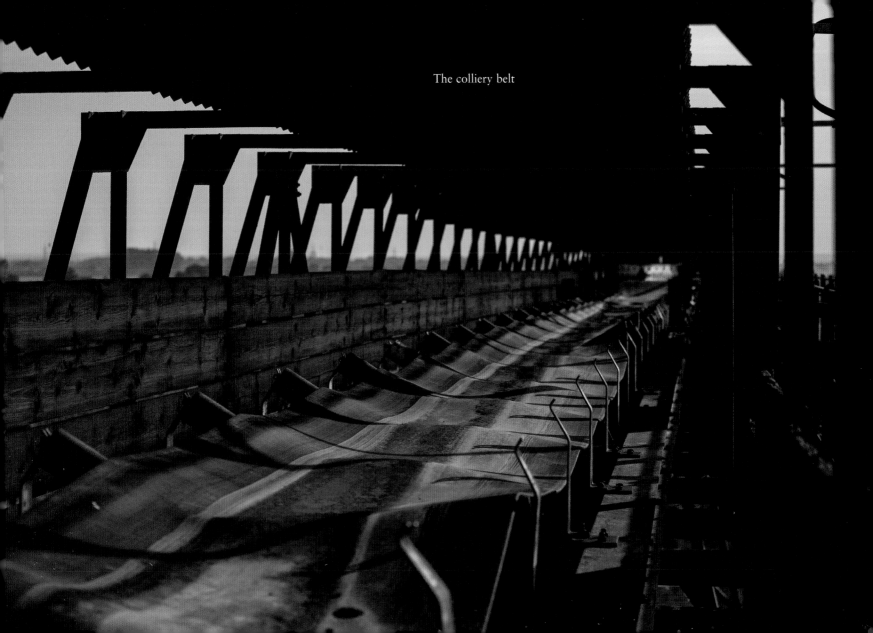

The colliery belt

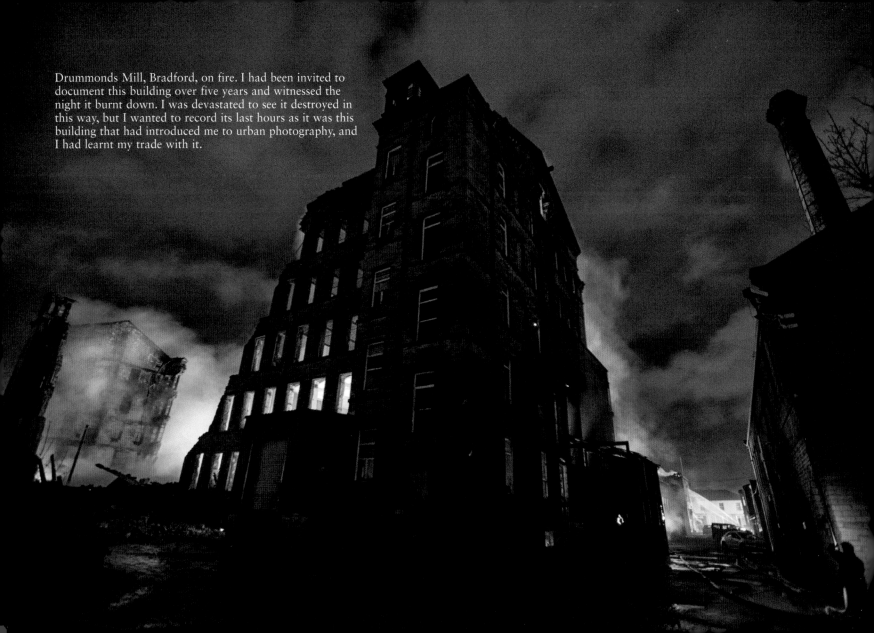

Drummonds Mill, Bradford, on fire. I had been invited to document this building over five years and witnessed the night it burnt down. I was devastated to see it destroyed in this way, but I wanted to record its last hours as it was this building that had introduced me to urban photography, and I had learnt my trade with it.

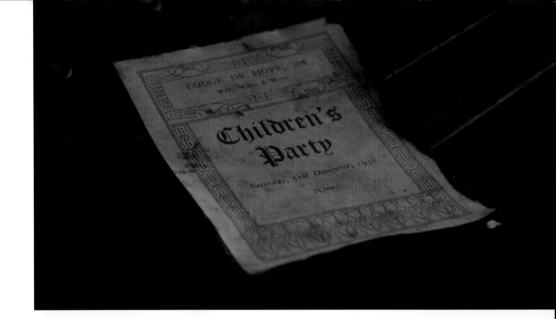

The Lodge of Hope. Invite for a children's party on
New Year's Eve, 1938.

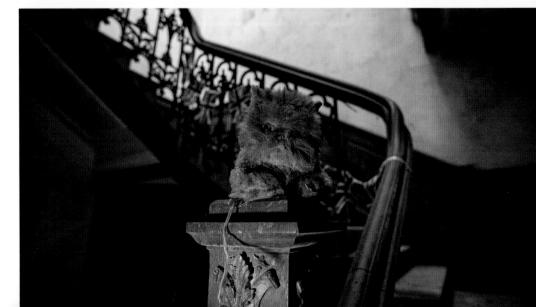

A strange encounter on the staircase of an abandoned
mansion in South Yorkshire

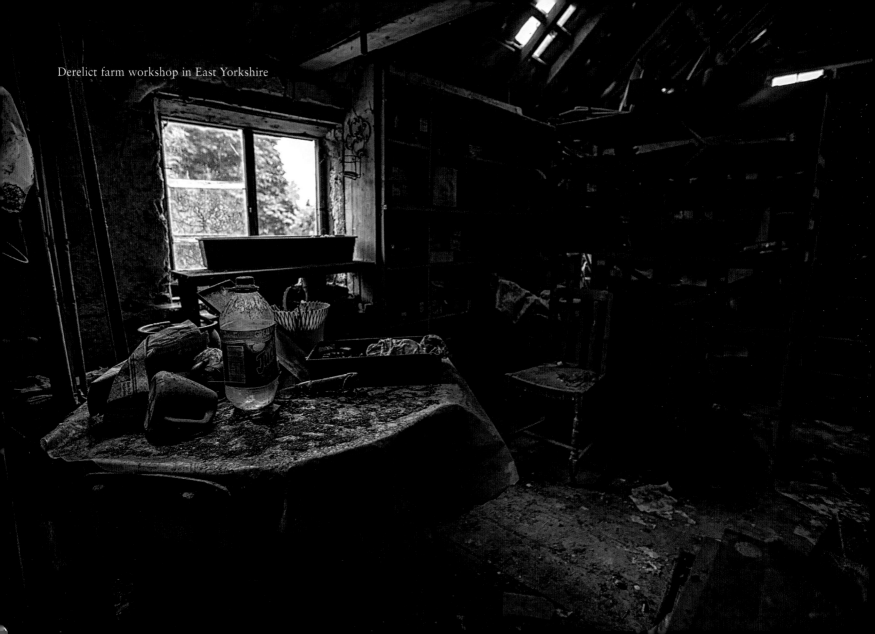

Derelict farm workshop in East Yorkshire

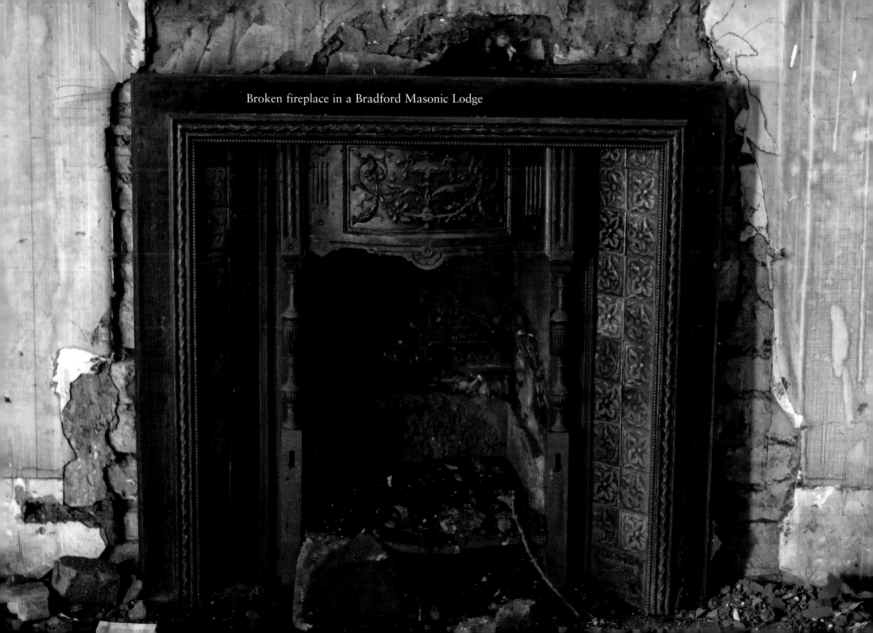
Broken fireplace in a Bradford Masonic Lodge

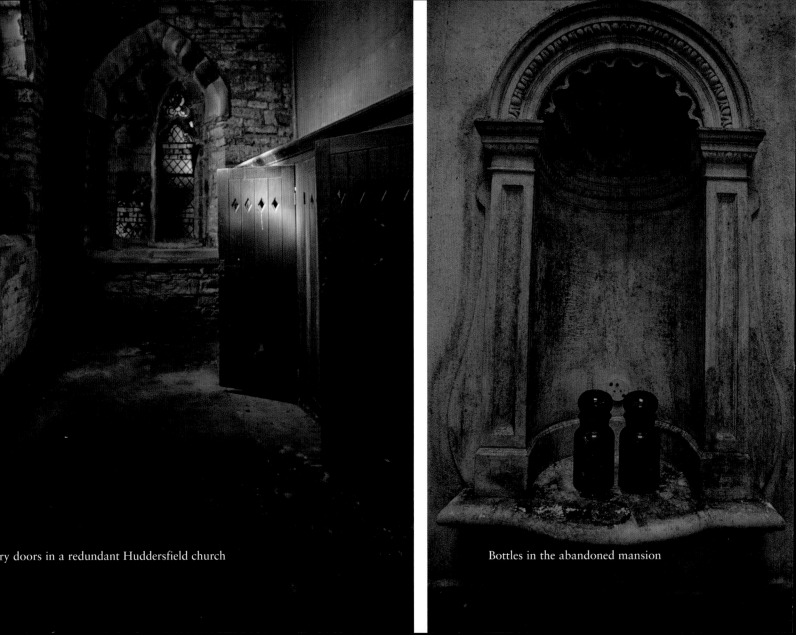

ry doors in a redundant Huddersfield church

Bottles in the abandoned mansion

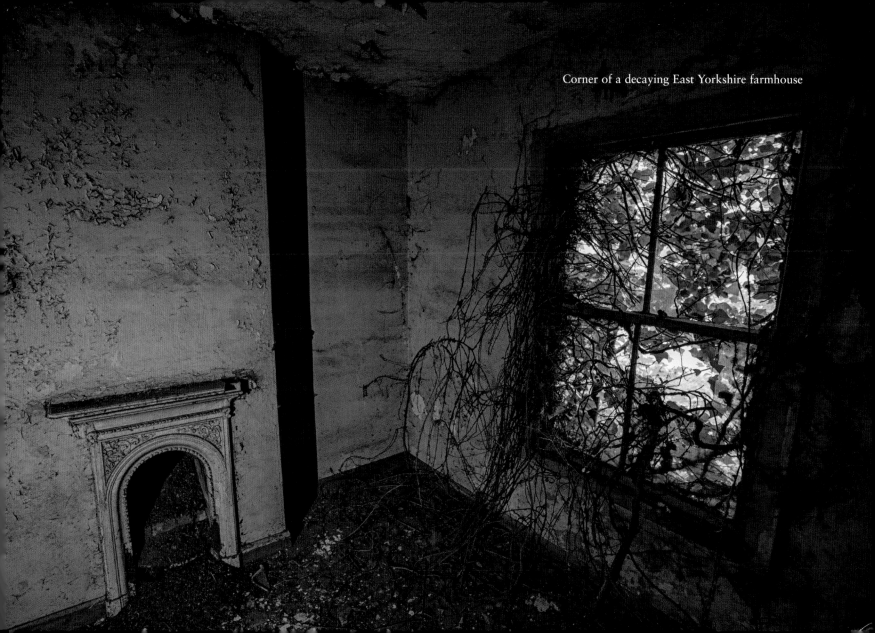

Corner of a decaying East Yorkshire farmhouse

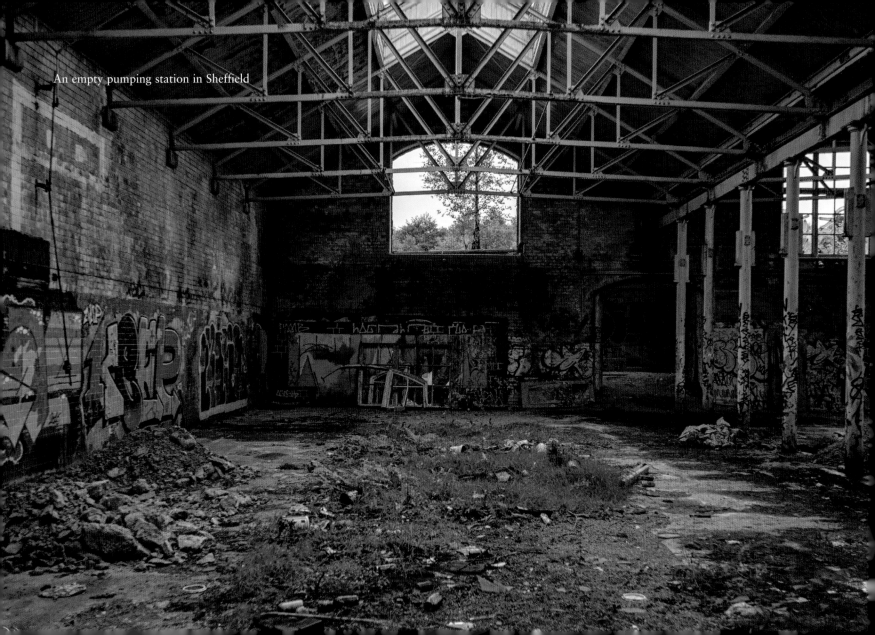
An empty pumping station in Sheffield

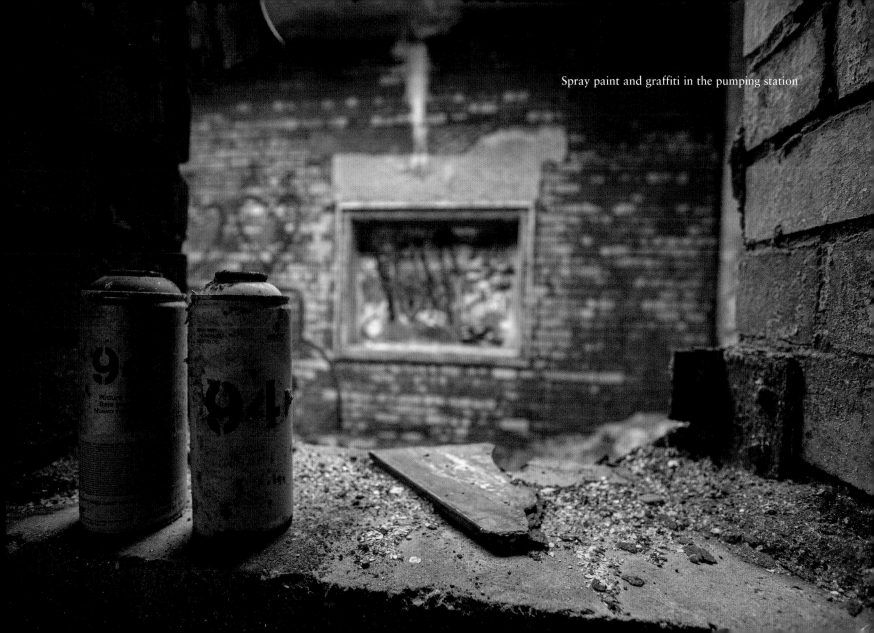

Spray paint and graffiti in the pumping station

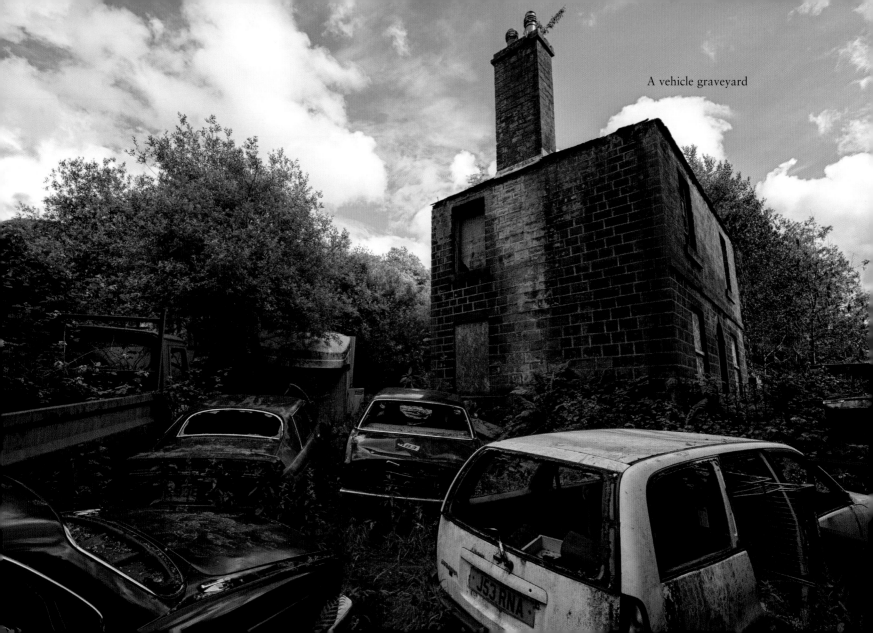

A vehicle graveyard

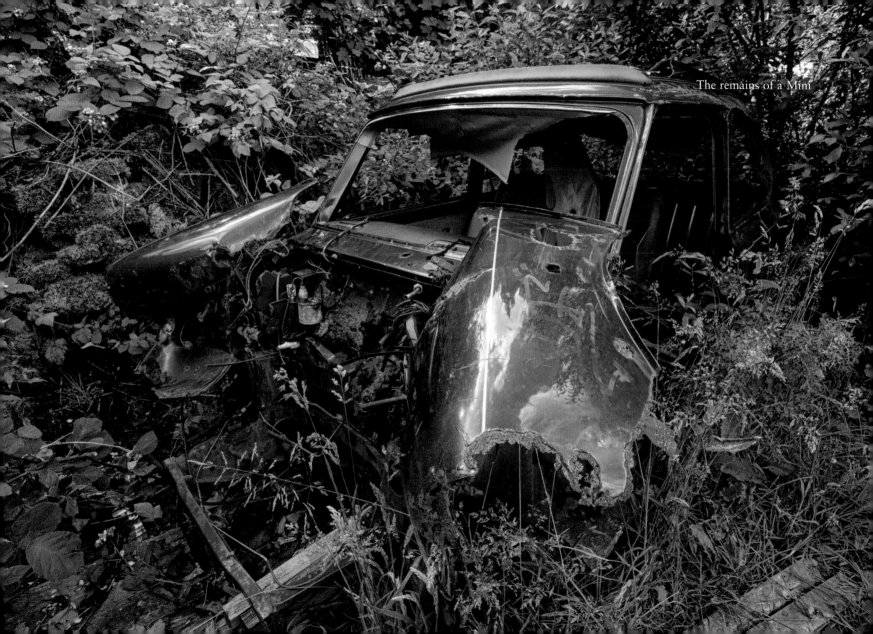

The remains of a Mini

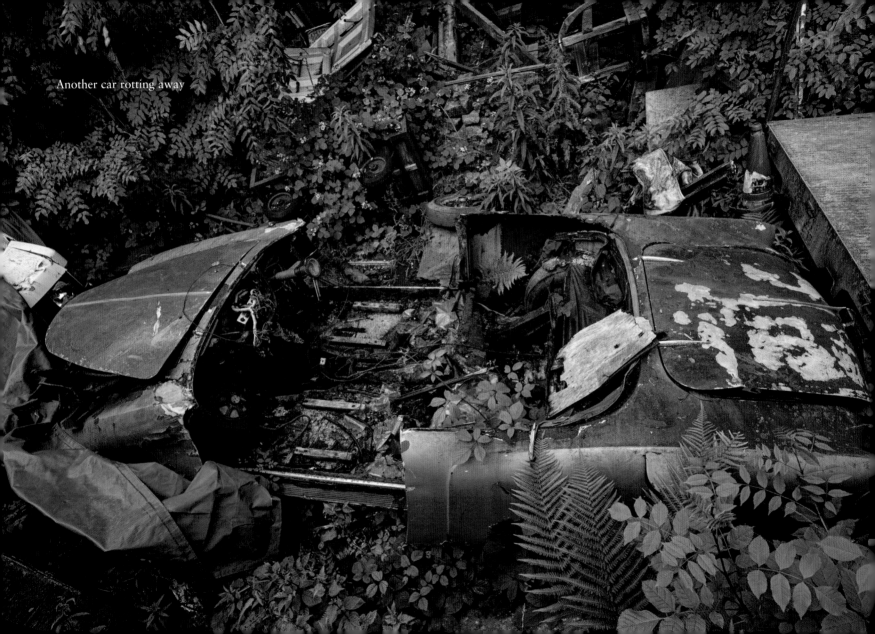

Another car rotting away

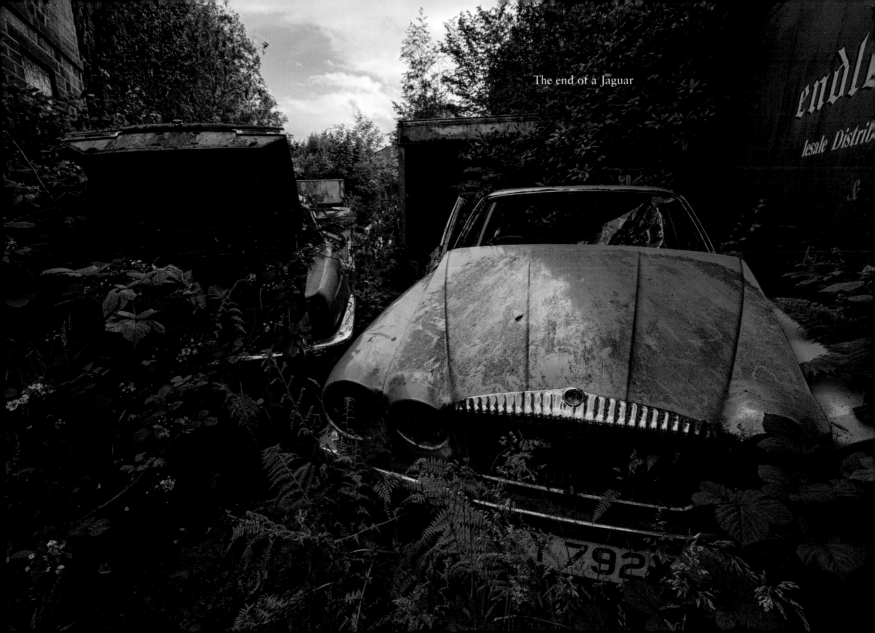

The end of a Jaguar

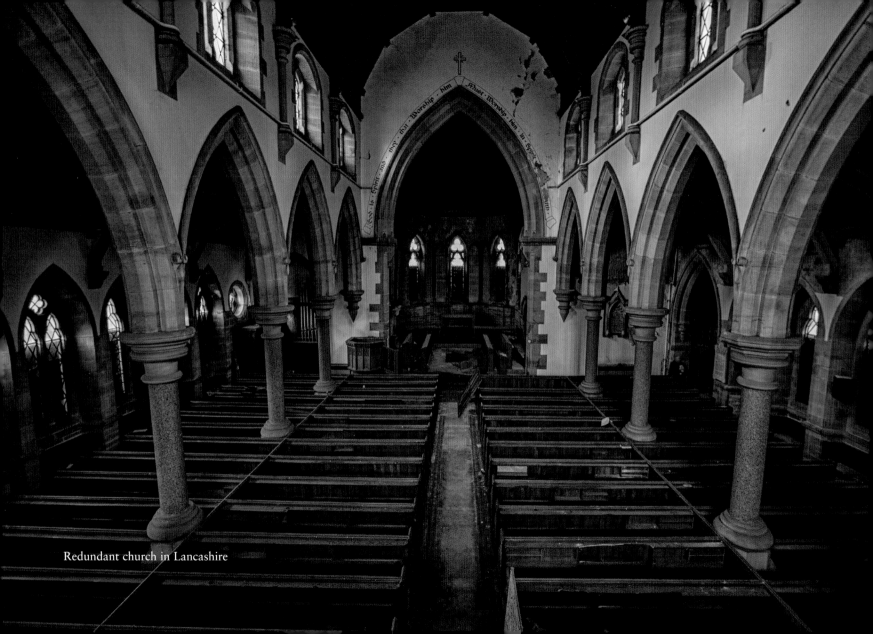

Redundant church in Lancashire

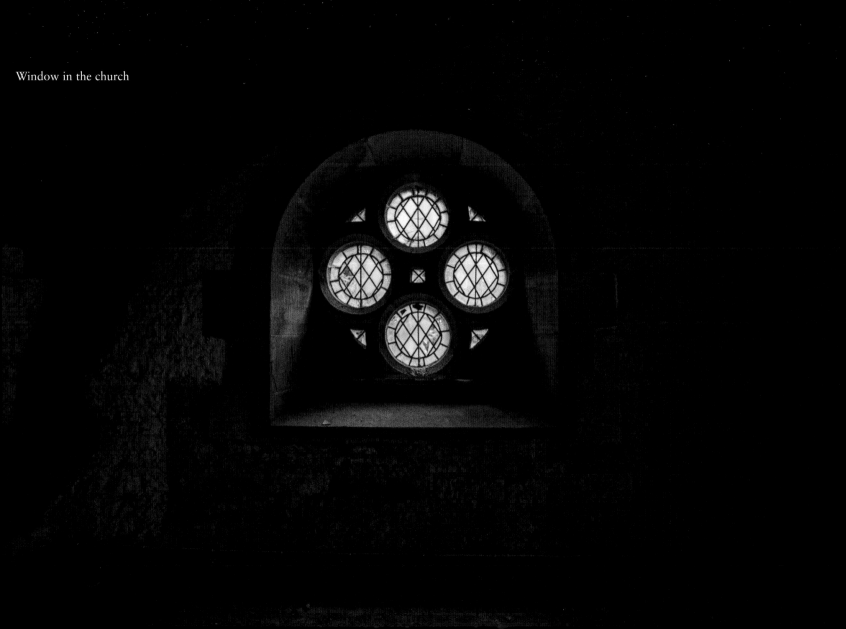

Window in the church

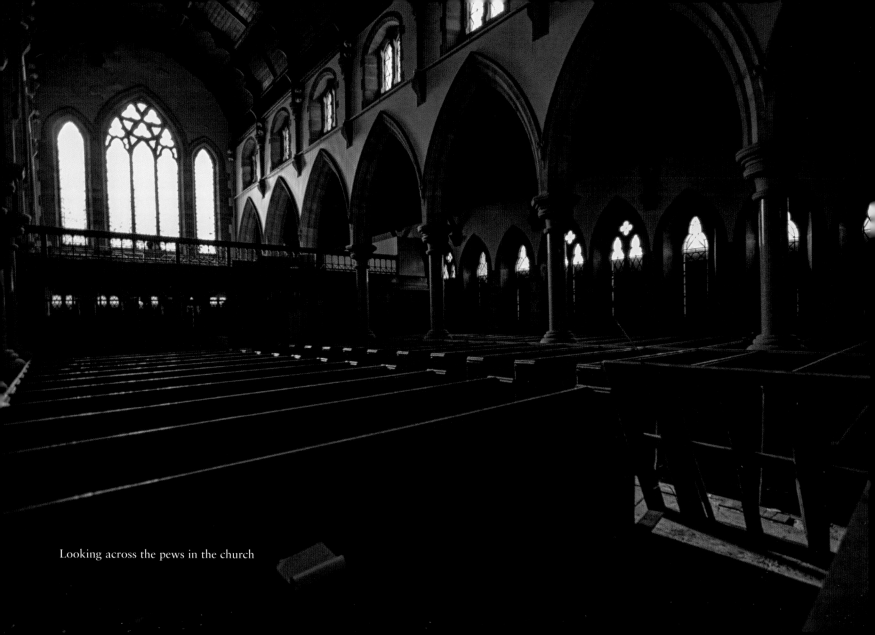

Looking across the pews in the church

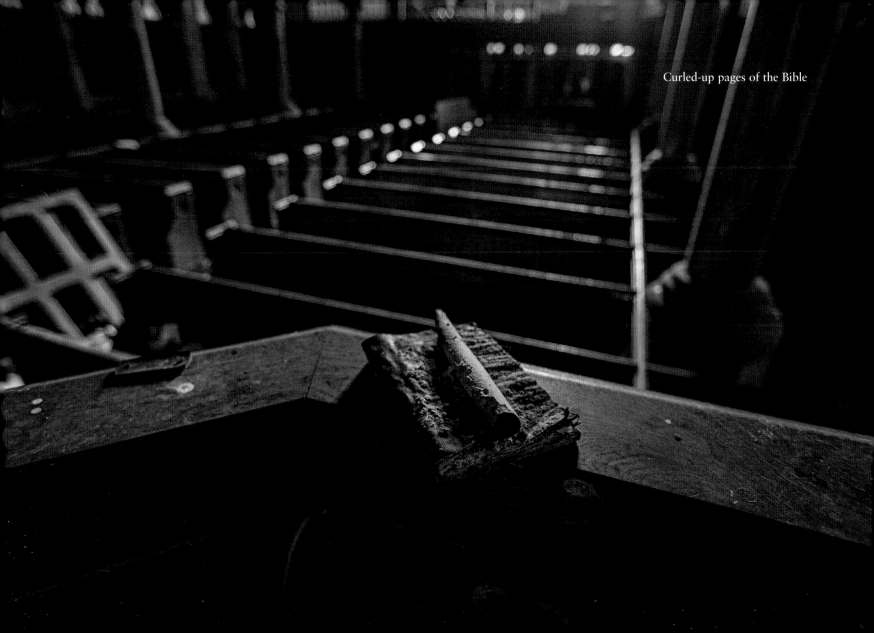

Curled-up pages of the Bible

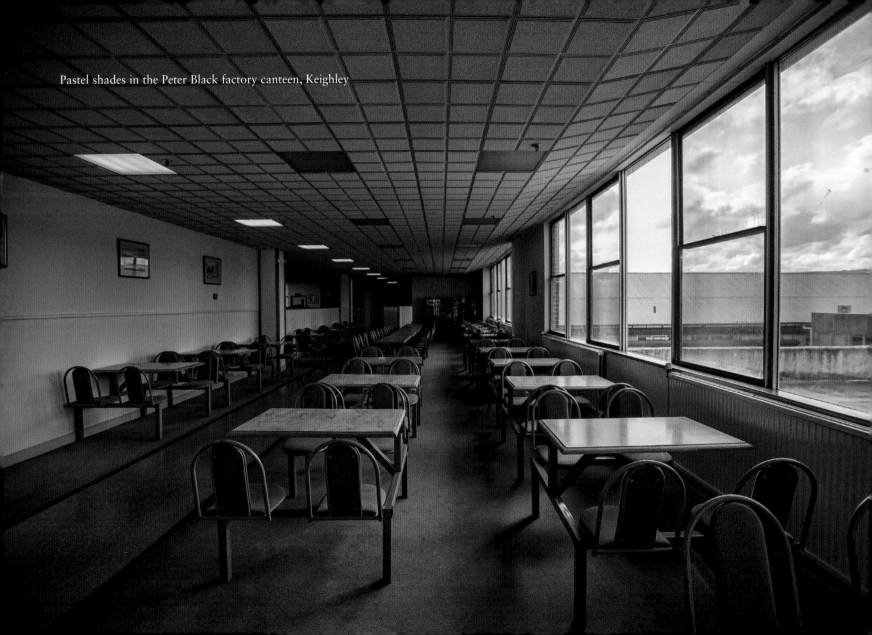
Pastel shades in the Peter Black factory canteen, Keighley

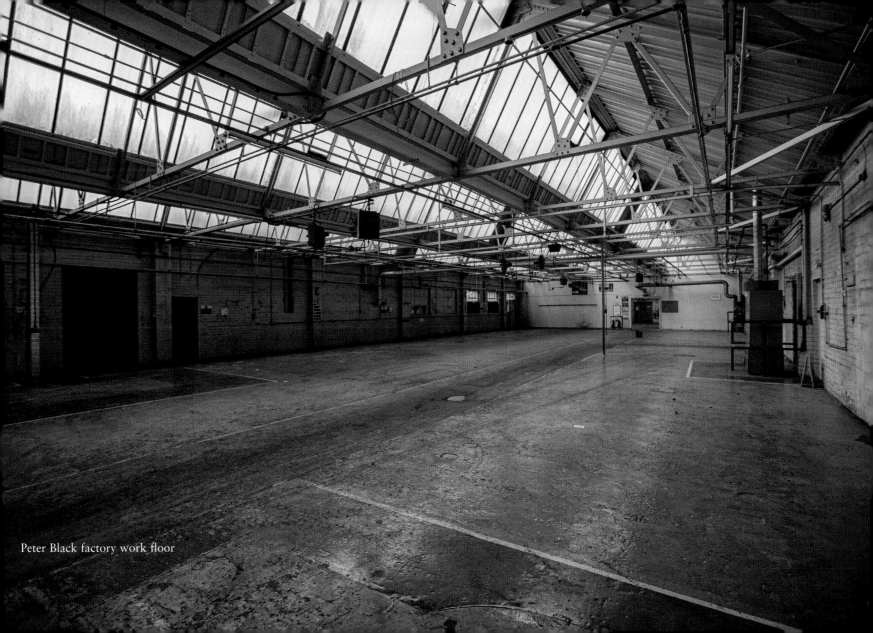

Peter Black factory work floor

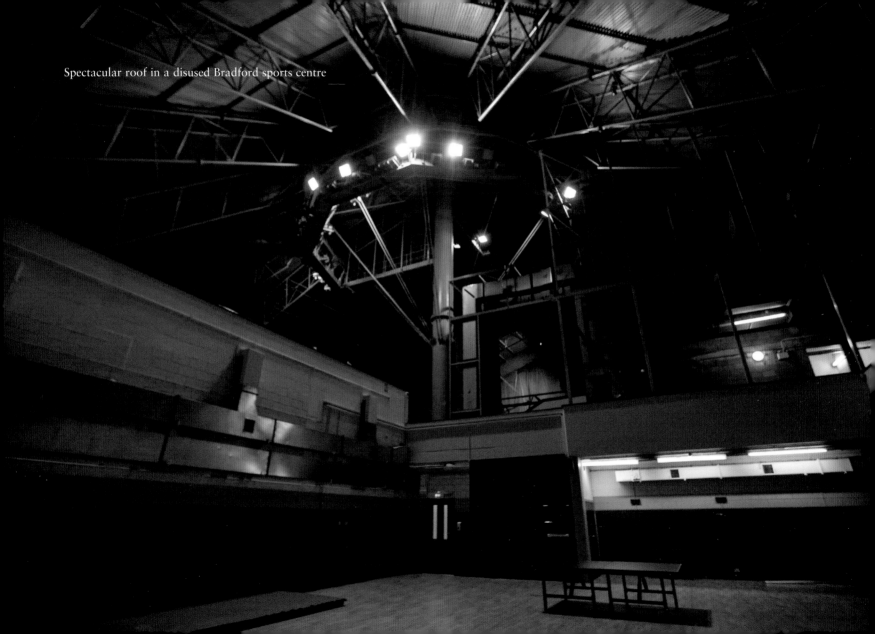

Spectacular roof in a disused Bradford sports centre

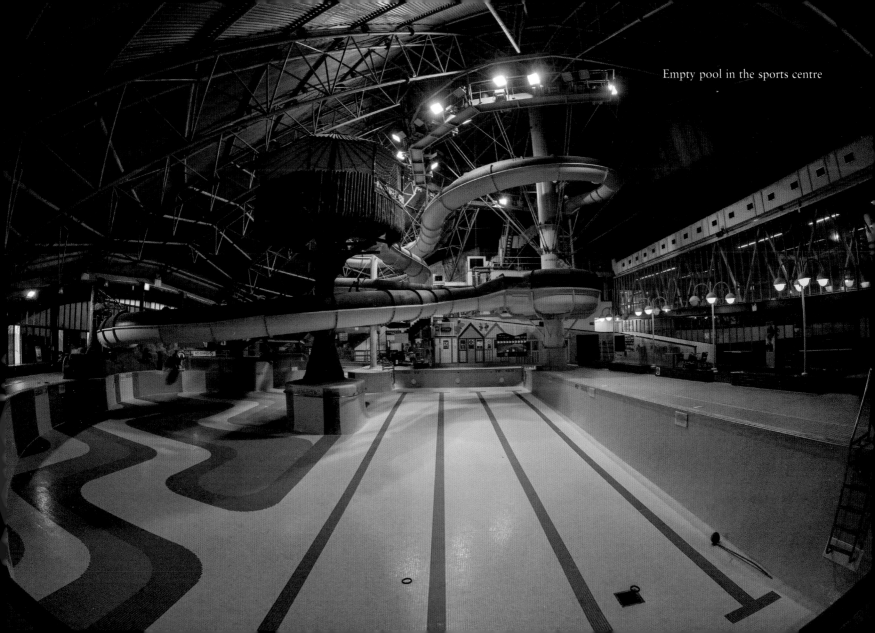

Empty pool in the sports centre

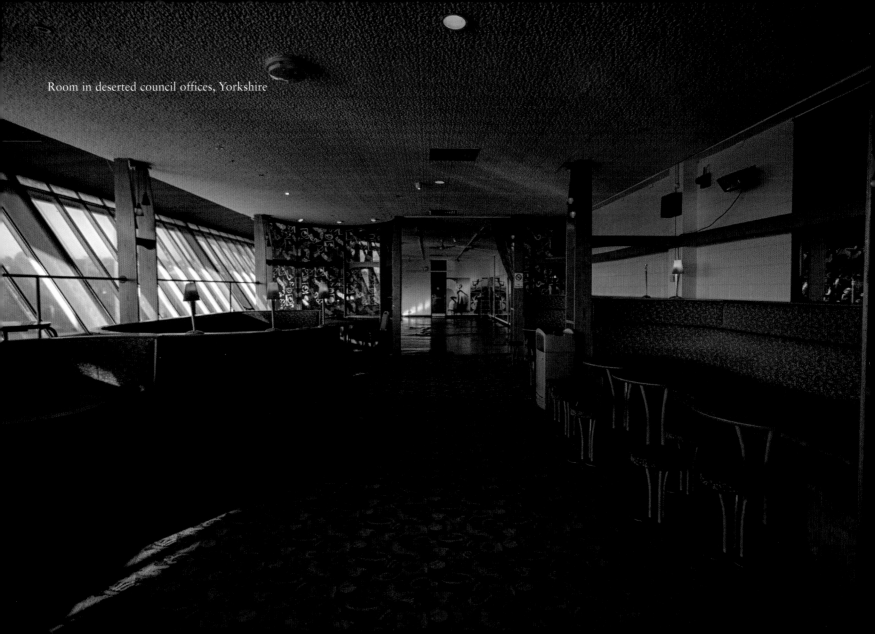

Room in deserted council offices, Yorkshire

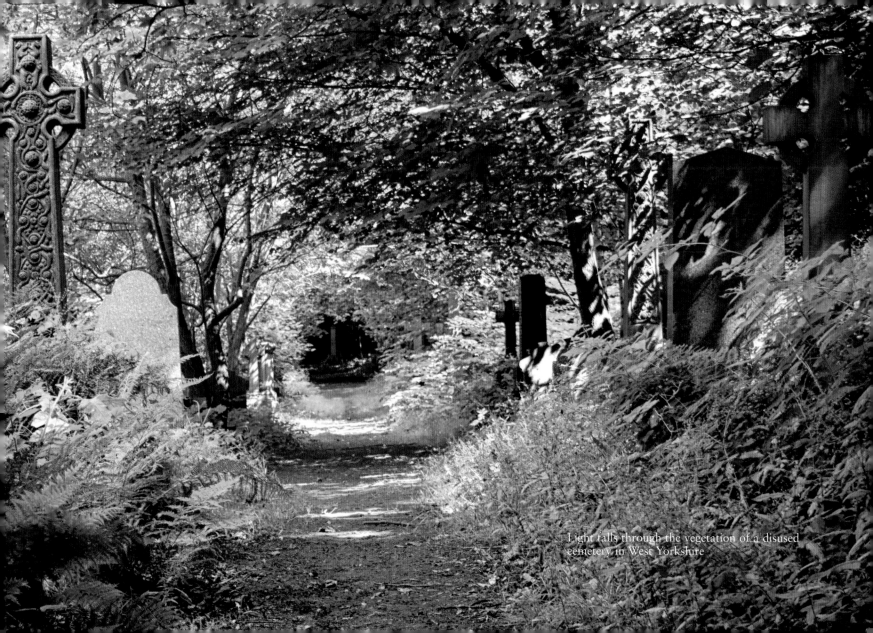

Light falls through the vegetation of a disused cemetery in West Yorkshire

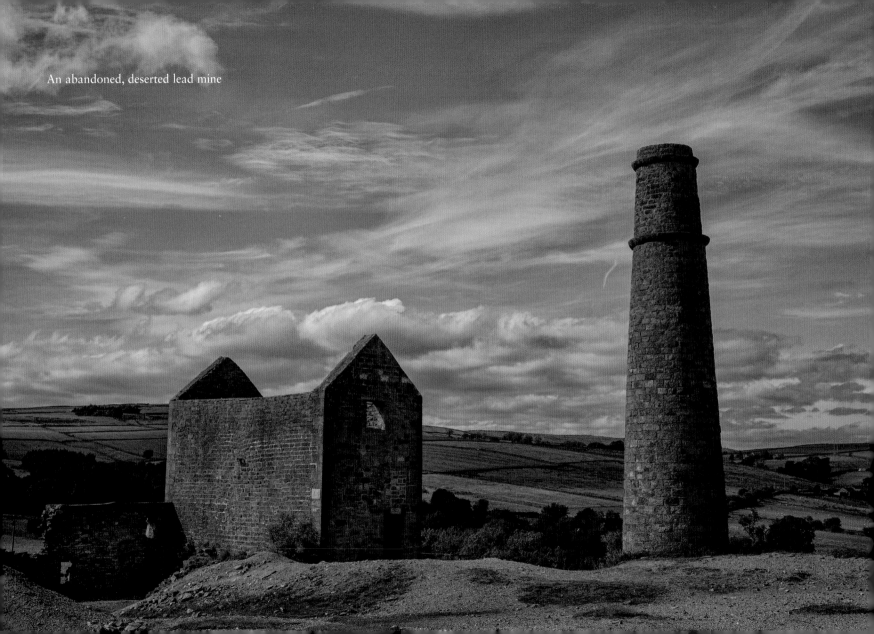

An abandoned, deserted lead mine

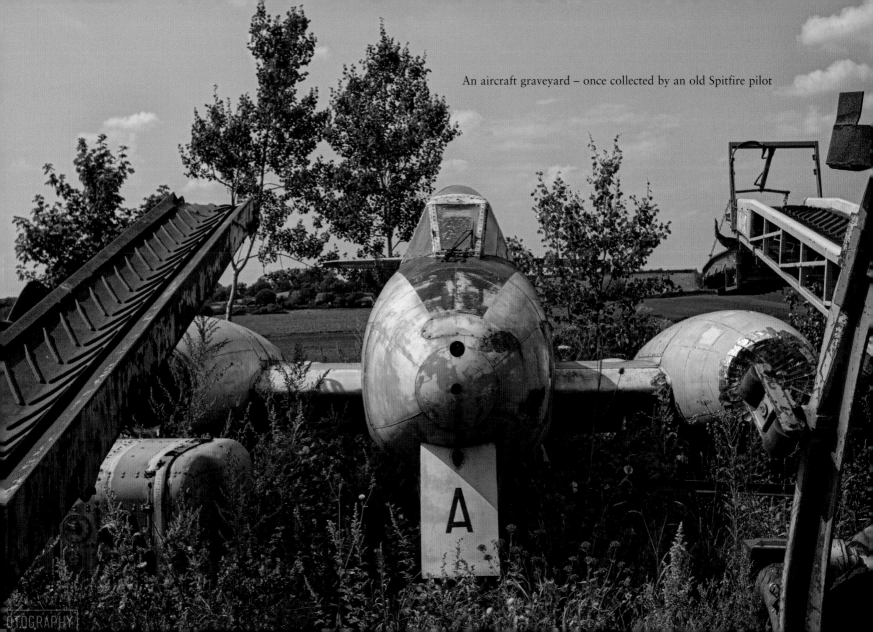

An aircraft graveyard – once collected by an old Spitfire pilot

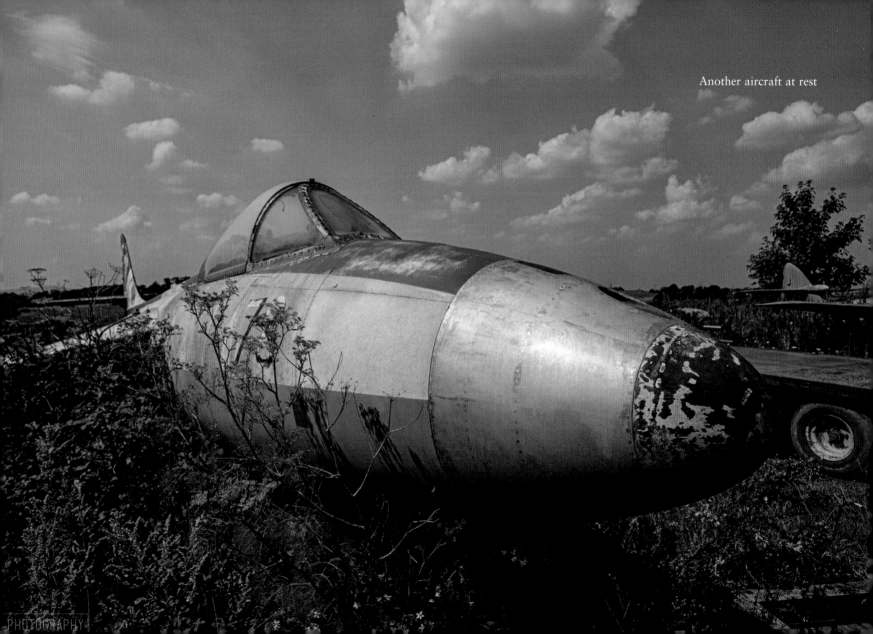

Another aircraft at rest

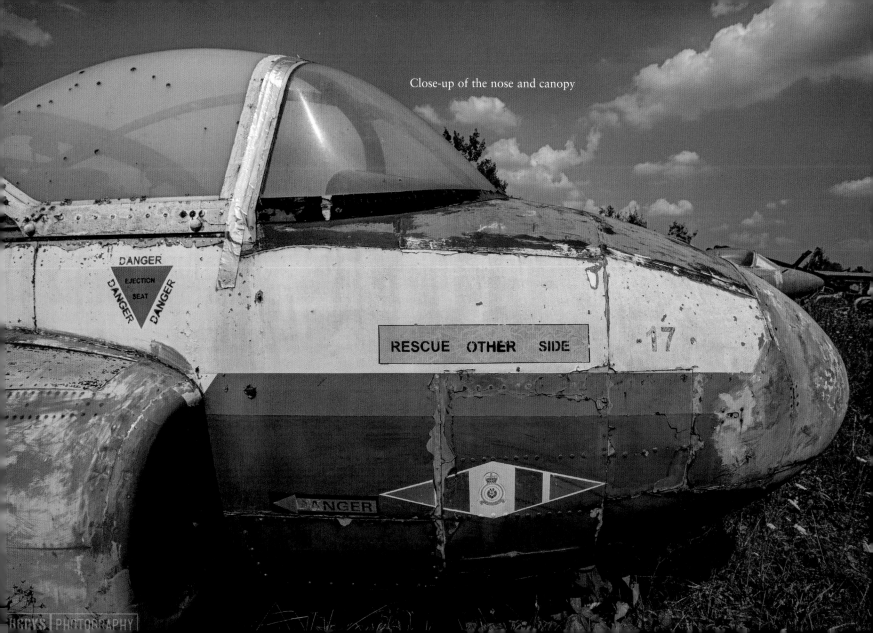

Close-up of the nose and canopy

DANGER
EJECTION SEAT
DANGER DANGER

RESCUE OTHER SIDE

17

DANGER

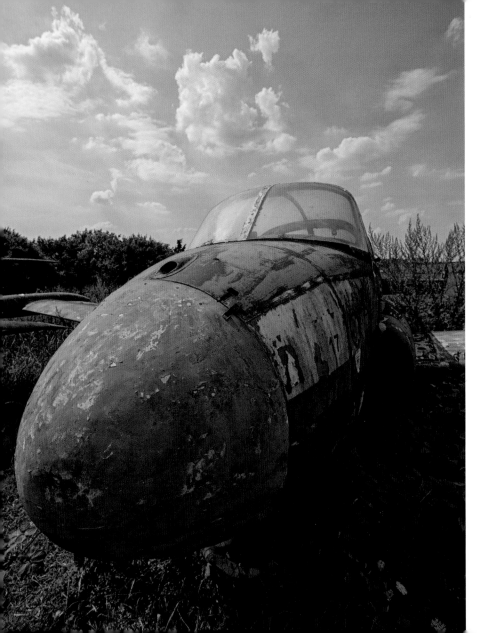

Looking down the nose

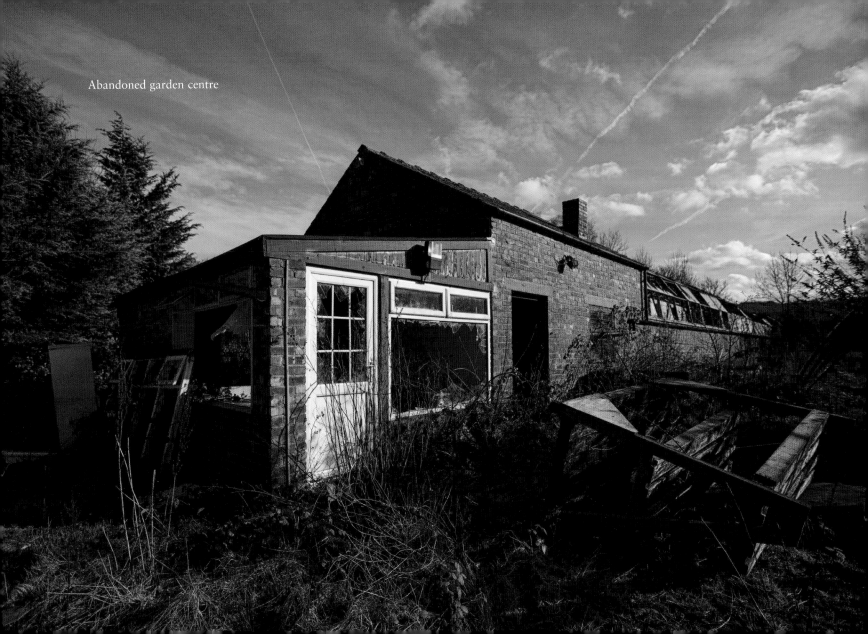

Abandoned garden centre

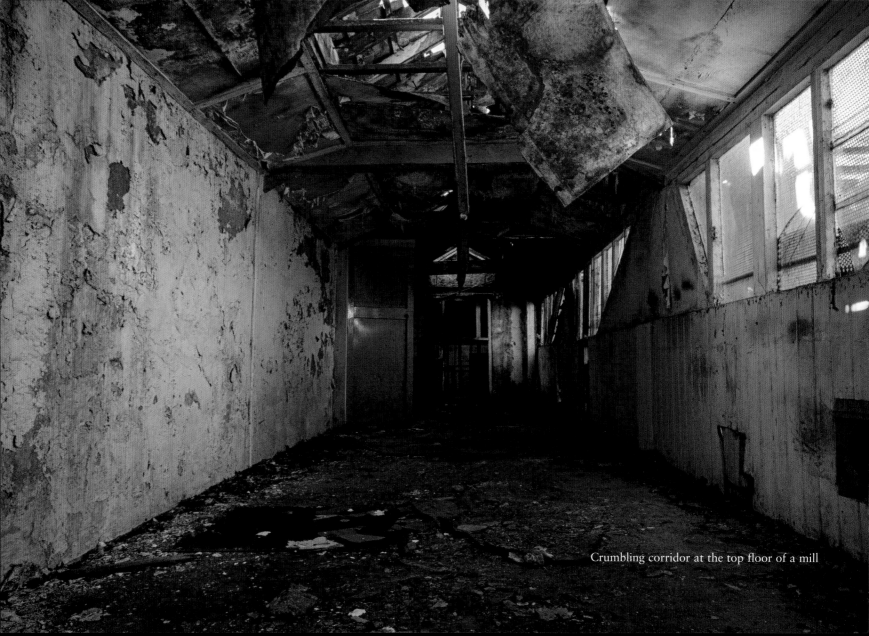
Crumbling corridor at the top floor of a mill

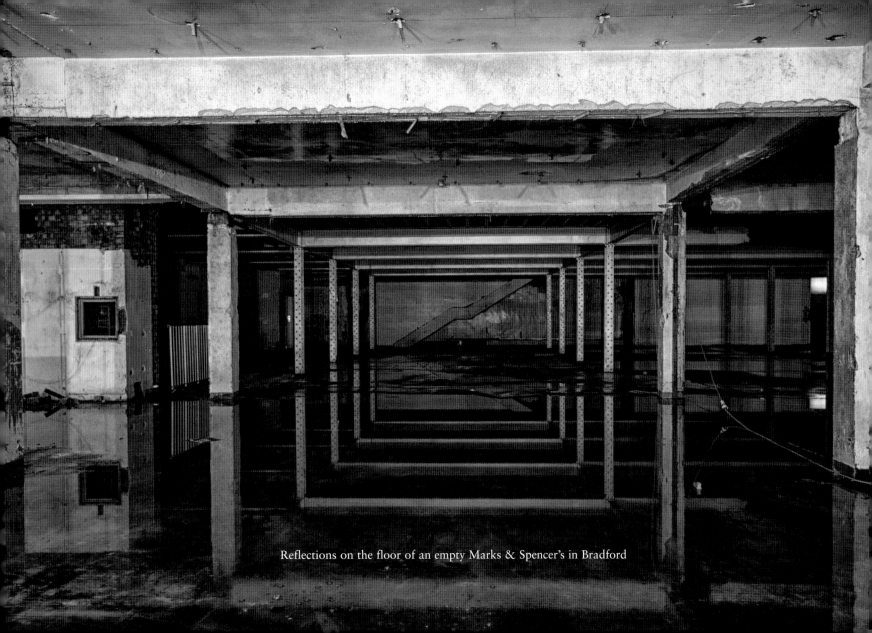

Reflections on the floor of an empty Marks & Spencer's in Bradford

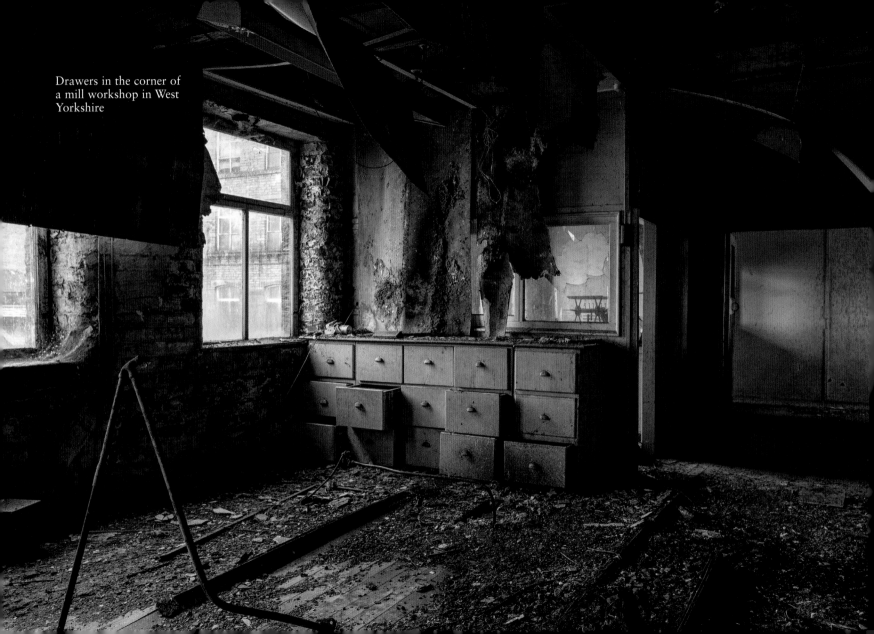

Drawers in the corner of
a mill workshop in West
Yorkshire

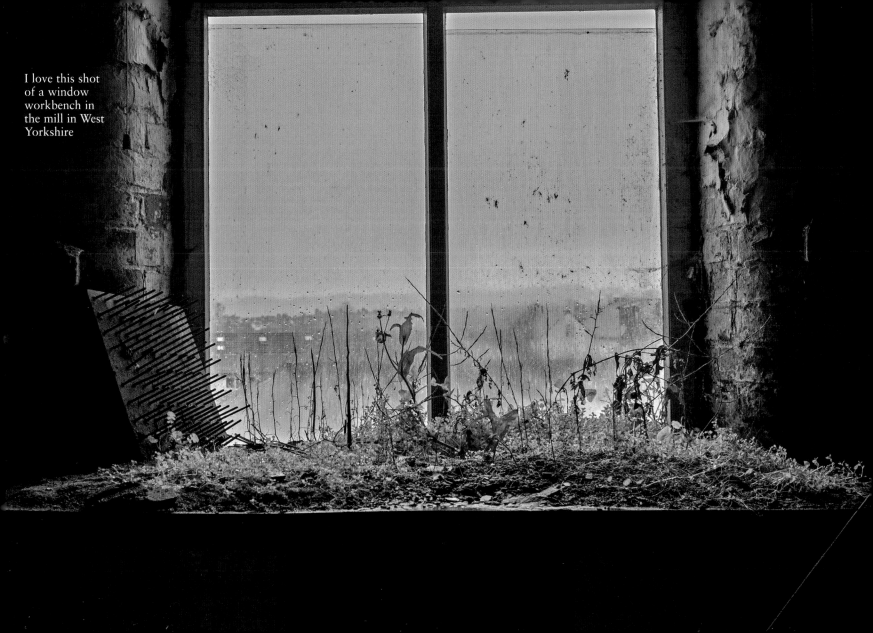

I love this shot of a window workbench in the mill in West Yorkshire

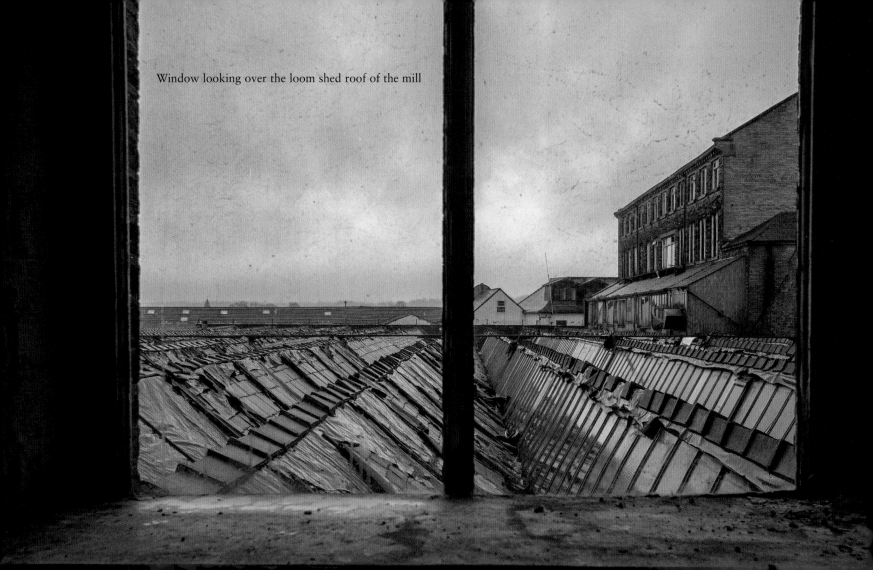

Window looking over the loom shed roof of the mill

Door in the mill

THIS DOOR
MUST BE KEPT
CLOSED DURING
NON -
WORKING HOURS

F.19

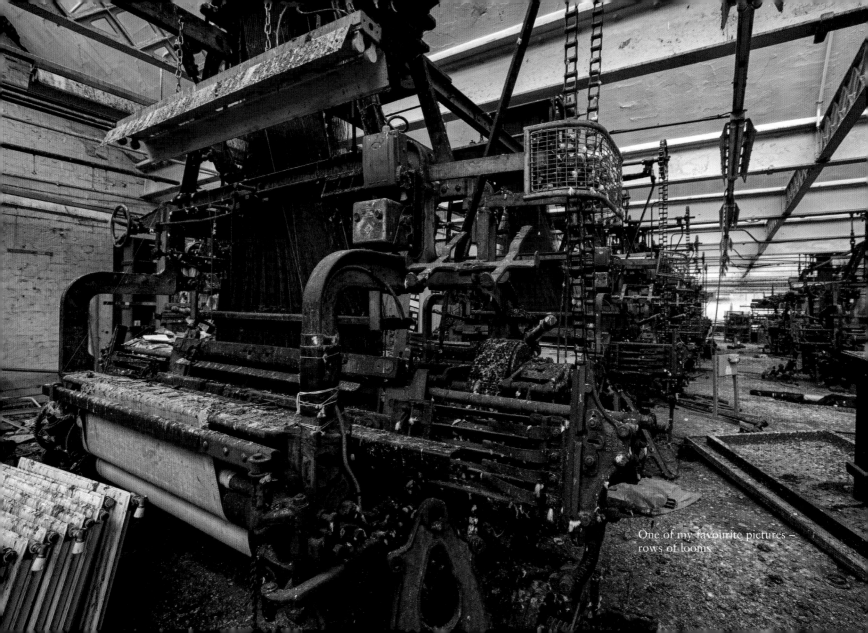

One of my favourite pictures –
rows of looms

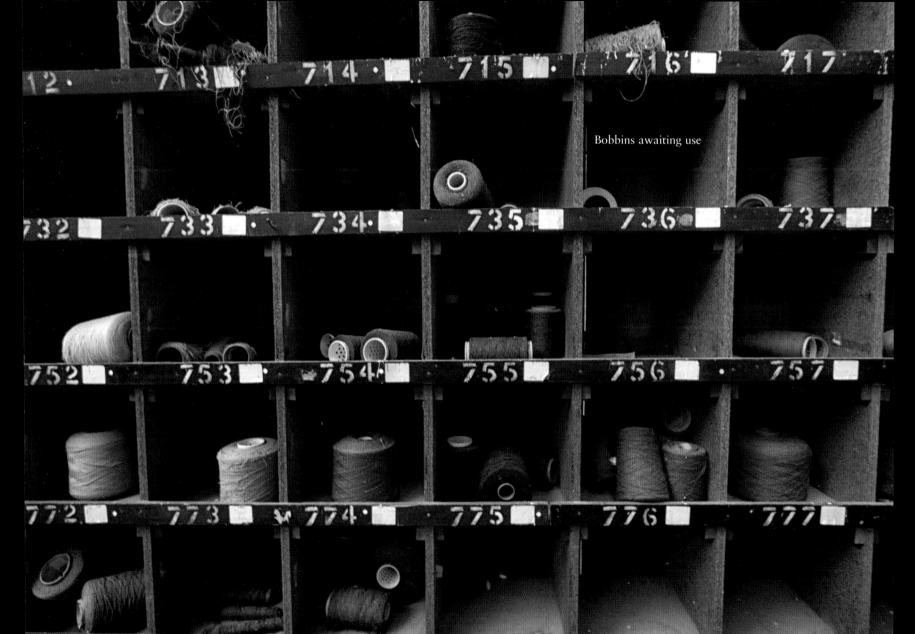

Bobbins awaiting use

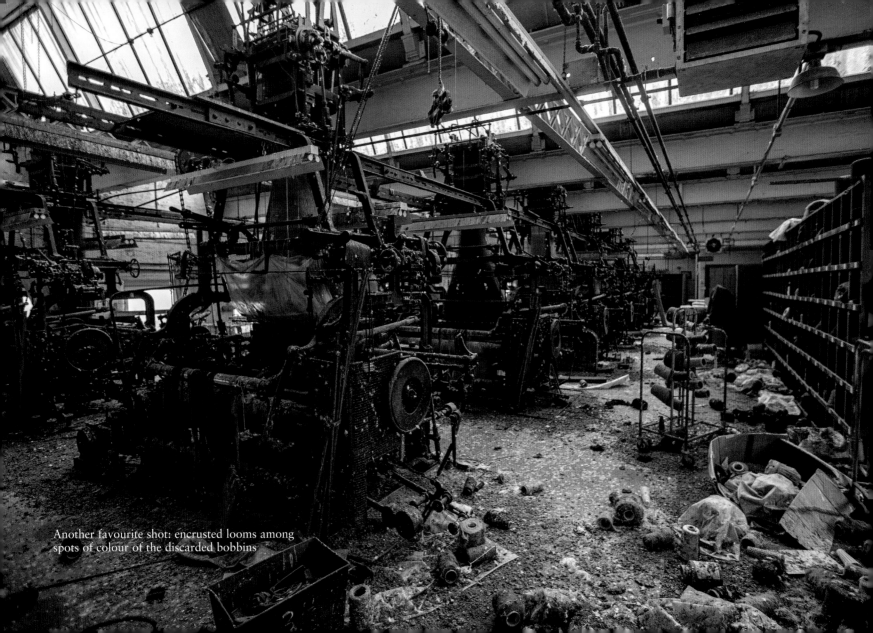

Another favourite shot: encrusted looms among
spots of colour of the discarded bobbins

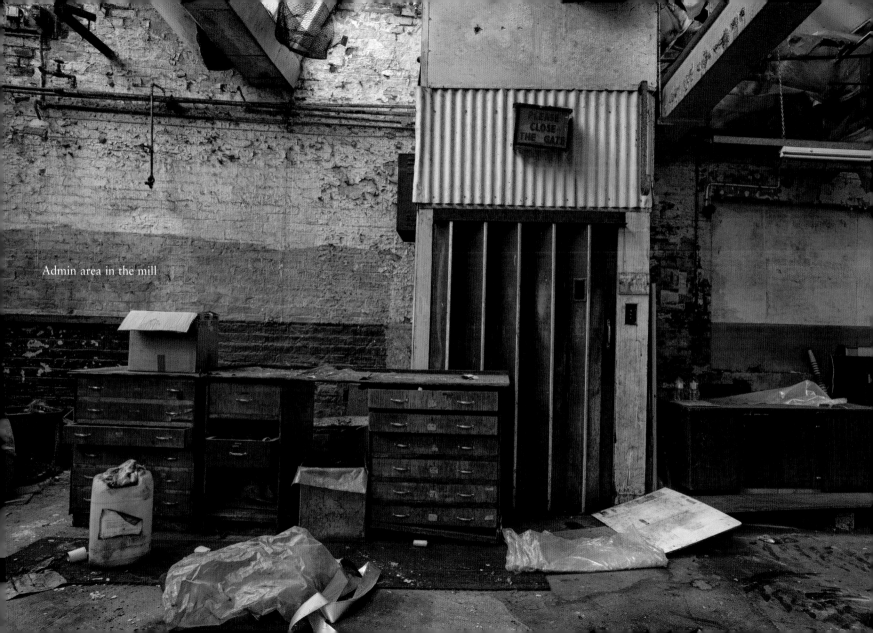

Admin area in the mill

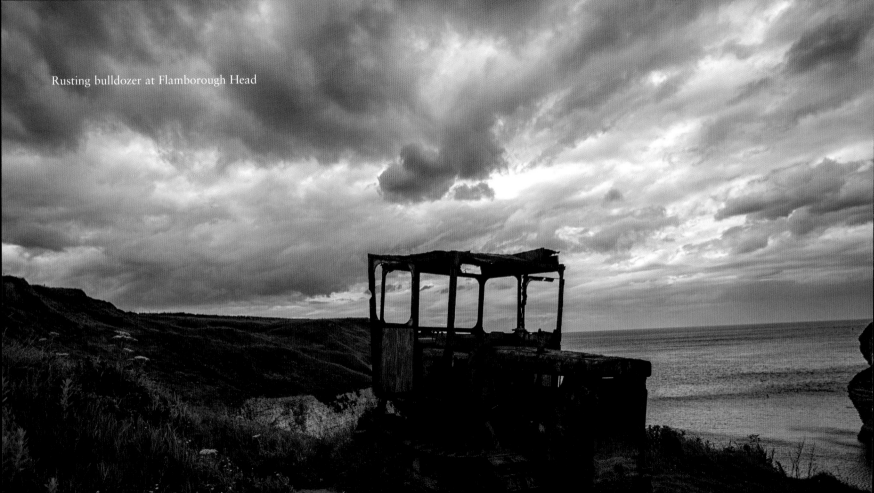

Rusting bulldozer at Flamborough Head

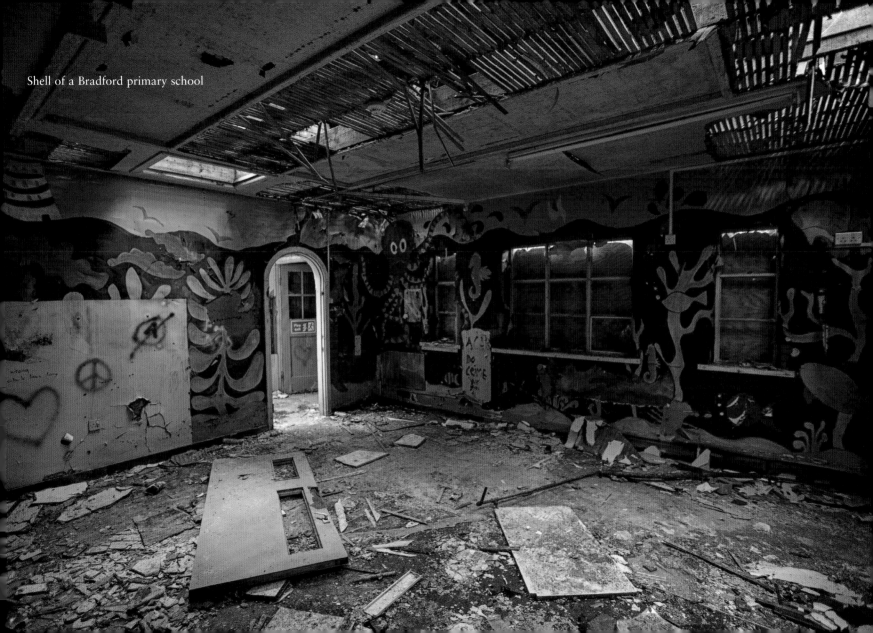

Shell of a Bradford primary school

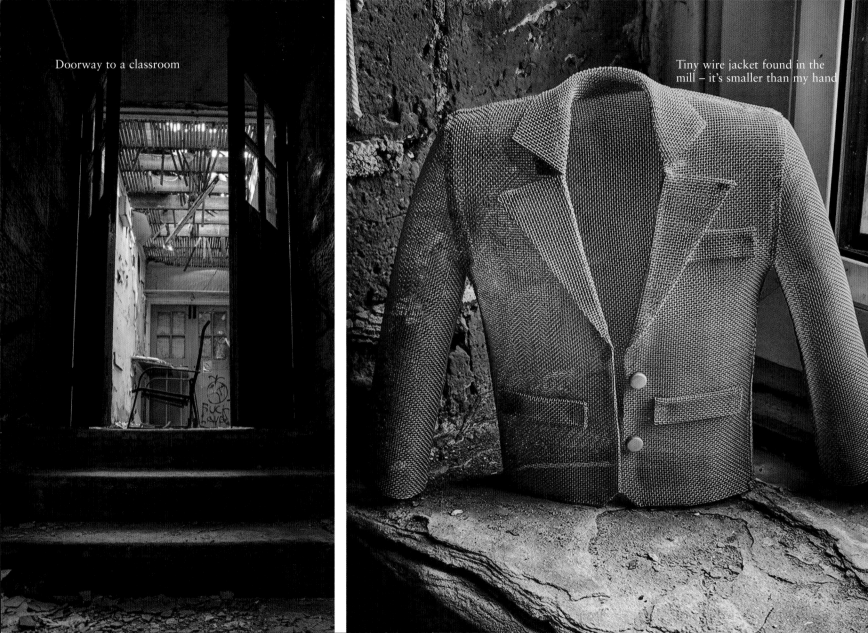

Doorway to a classroom

Tiny wire jacket found in the mill – it's smaller than my hand

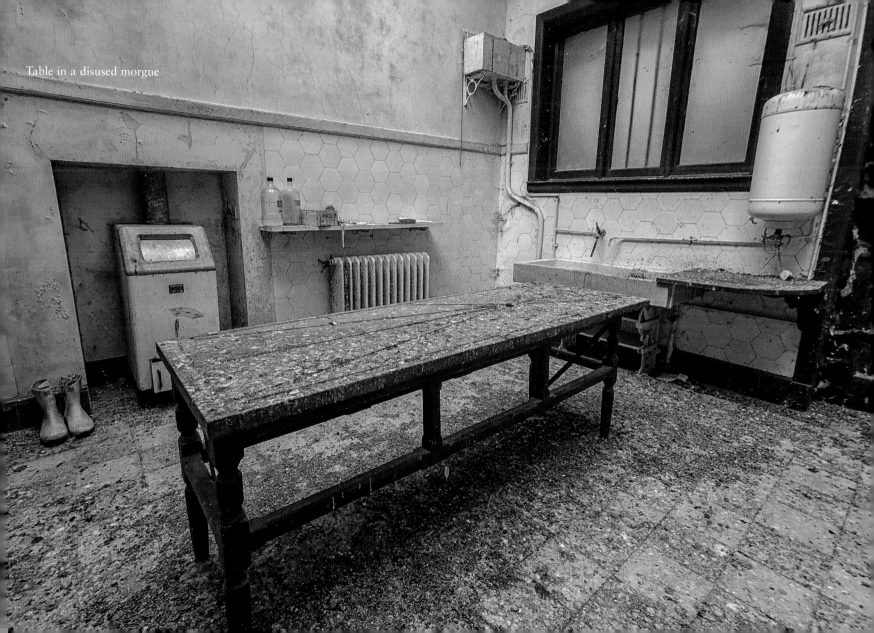

Table in a disused morgue

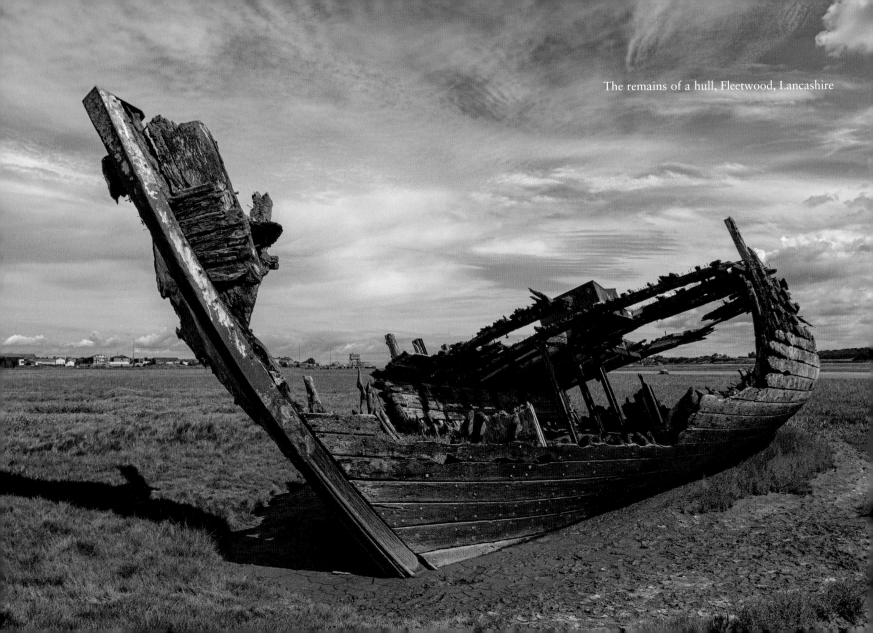

The remains of a hull, Fleetwood, Lancashire

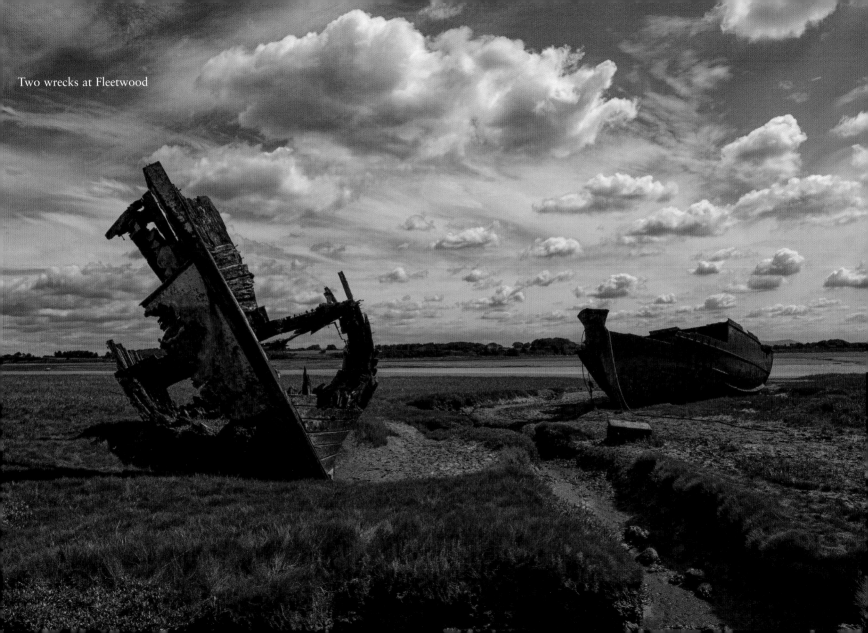
Two wrecks at Fleetwood

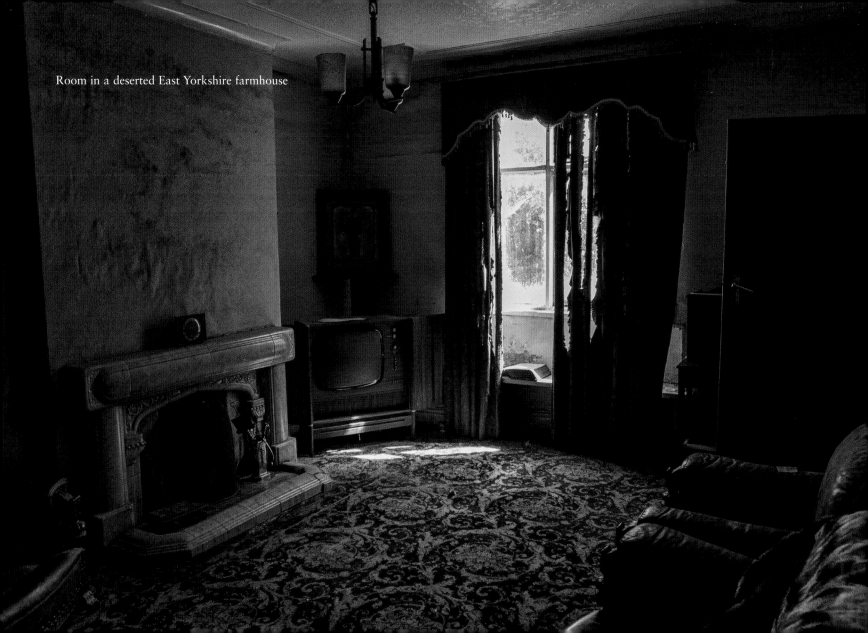

Room in a deserted East Yorkshire farmhouse

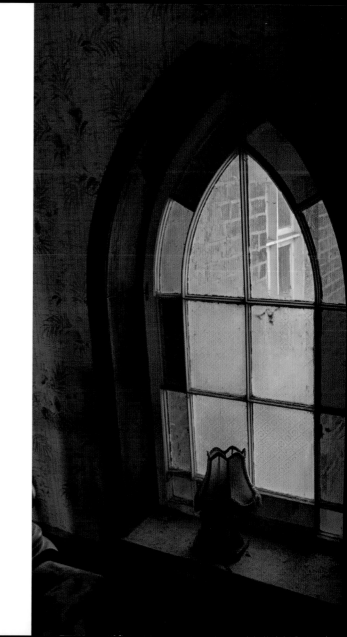

Stained-glass window in the farmhouse

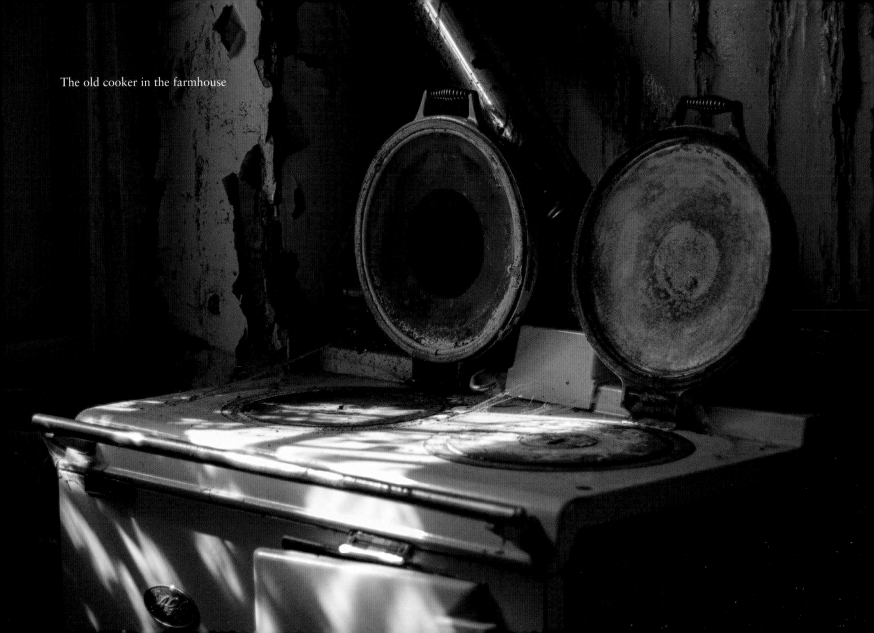

The old cooker in the farmhouse

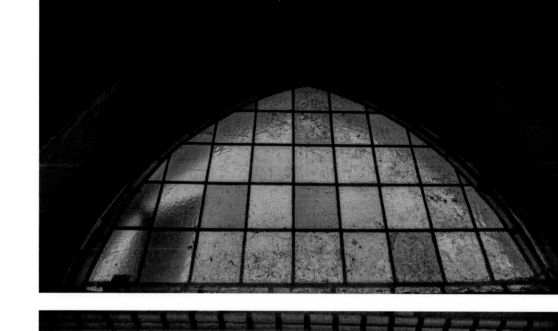

Stained-glass window in a church in Bradford

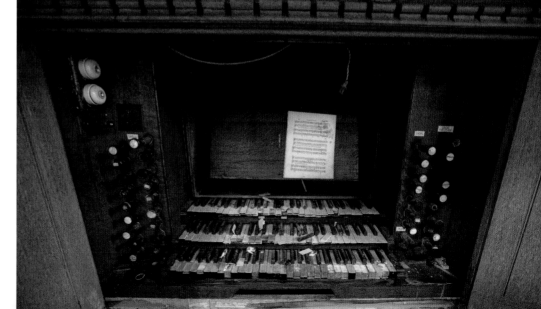

Rotting organ in a church in Lancashire

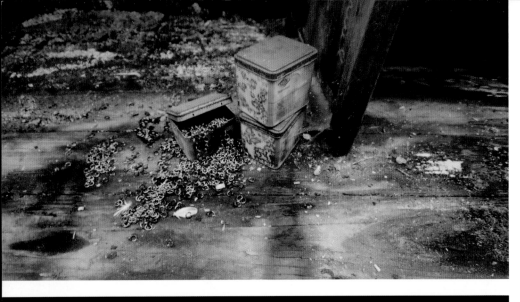

Found on the floor of the mill

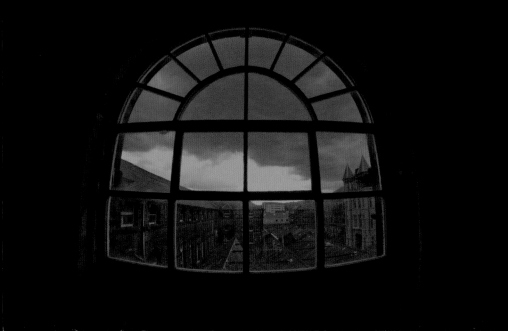

View from a mill window

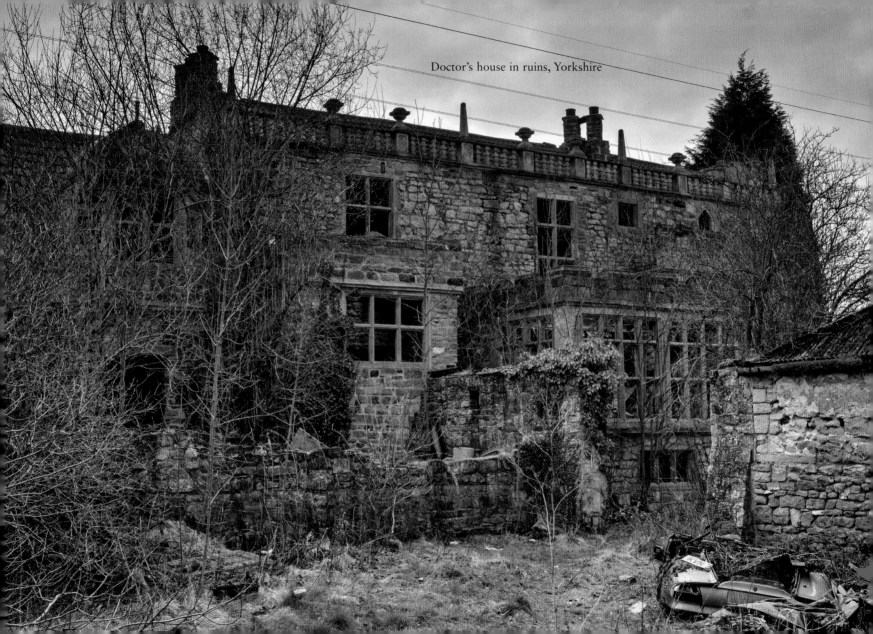

Doctor's house in ruins, Yorkshire

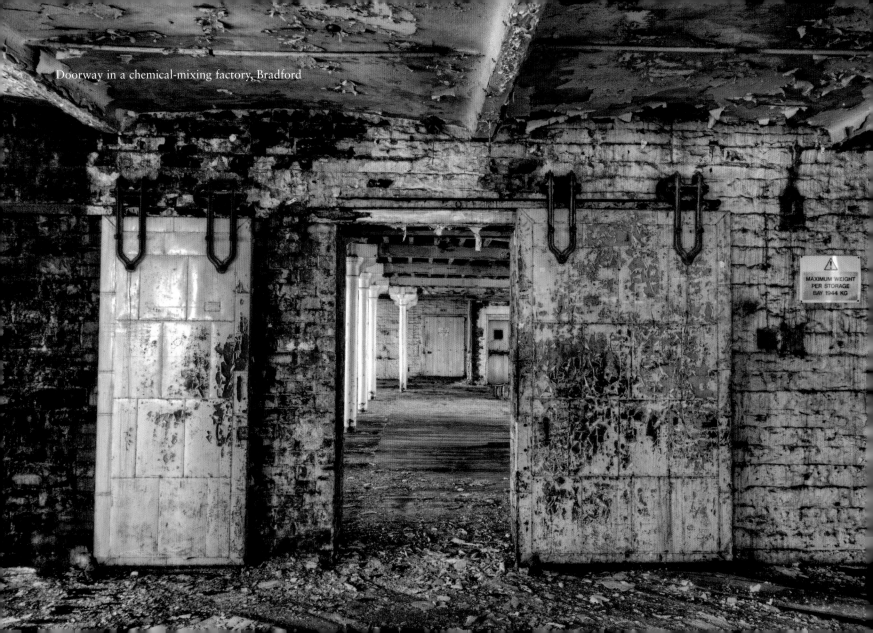

Doorway in a chemical-mixing factory, Bradford

⚠️ MAXIMUM WEIGHT
PER STORAGE
BAY 1944 KG

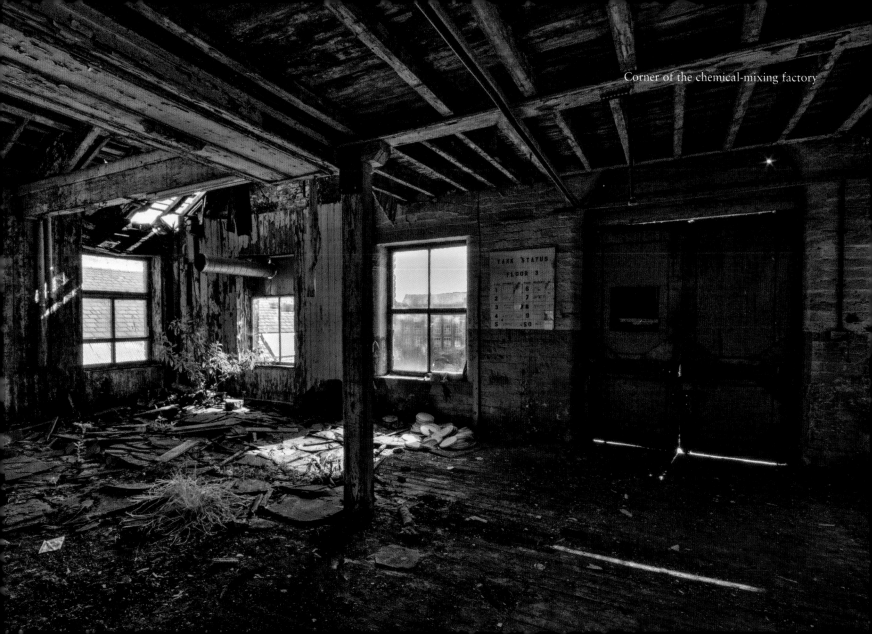

Corner of the chemical-mixing factory

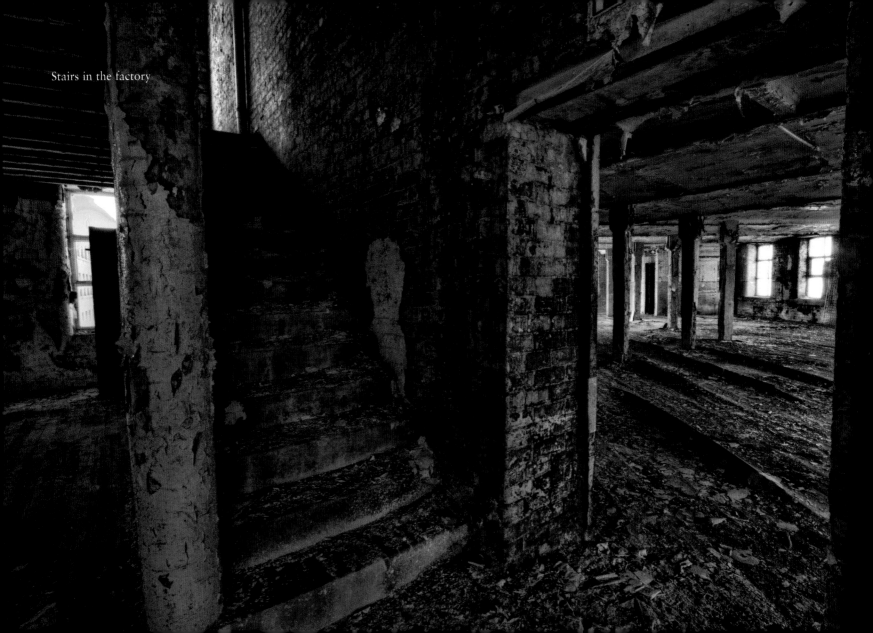
Stairs in the factory

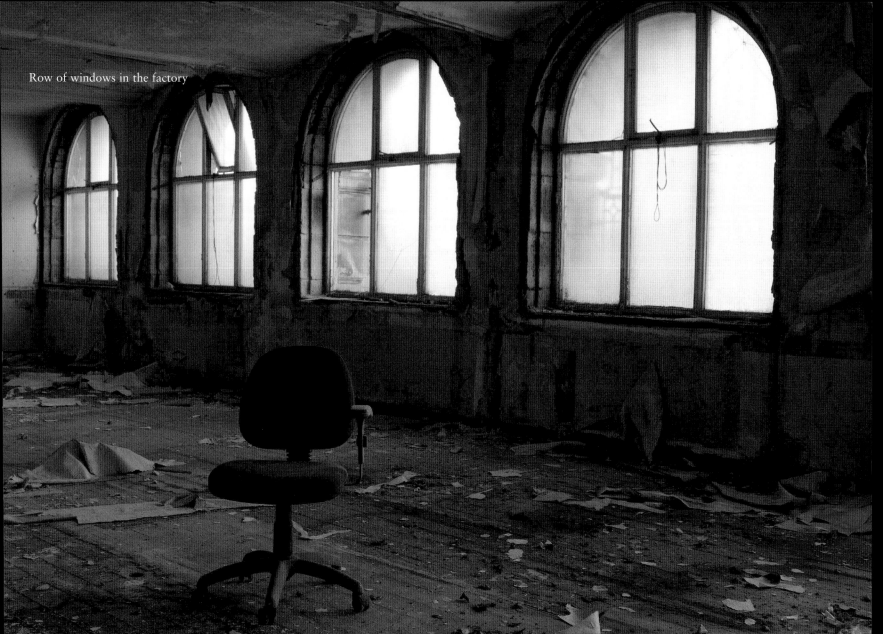

Row of windows in the factory

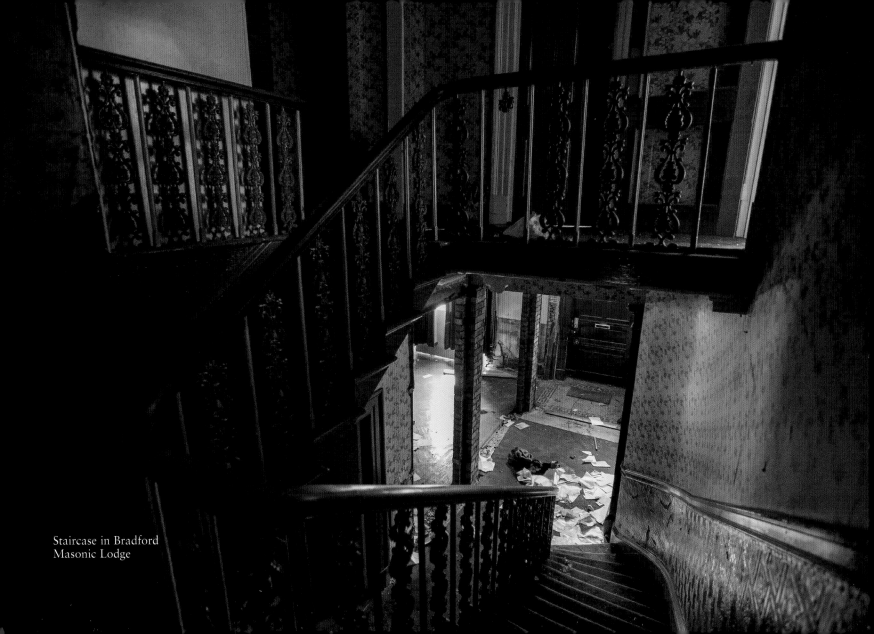

Staircase in Bradford
Masonic Lodge

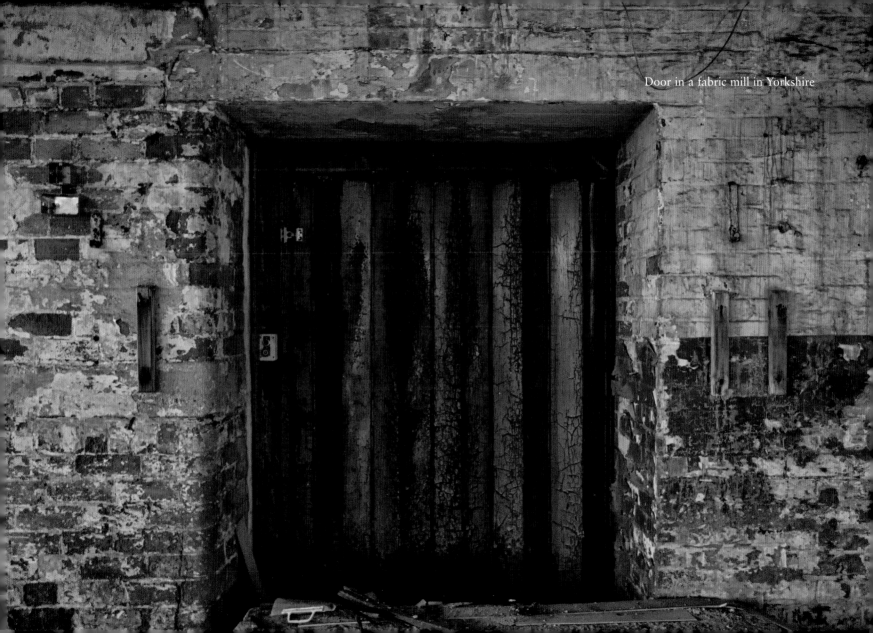
Door in a fabric mill in Yorkshire

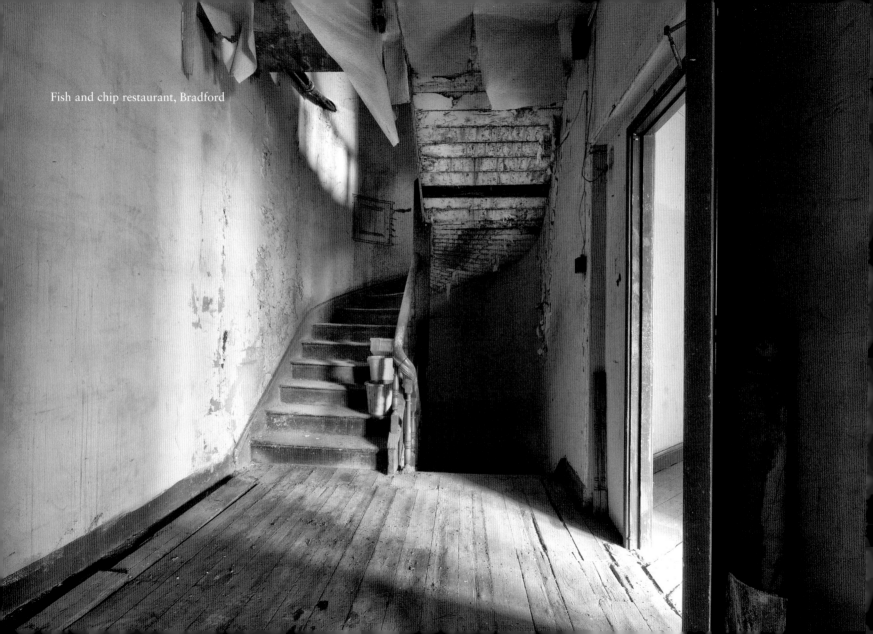

Fish and chip restaurant, Bradford

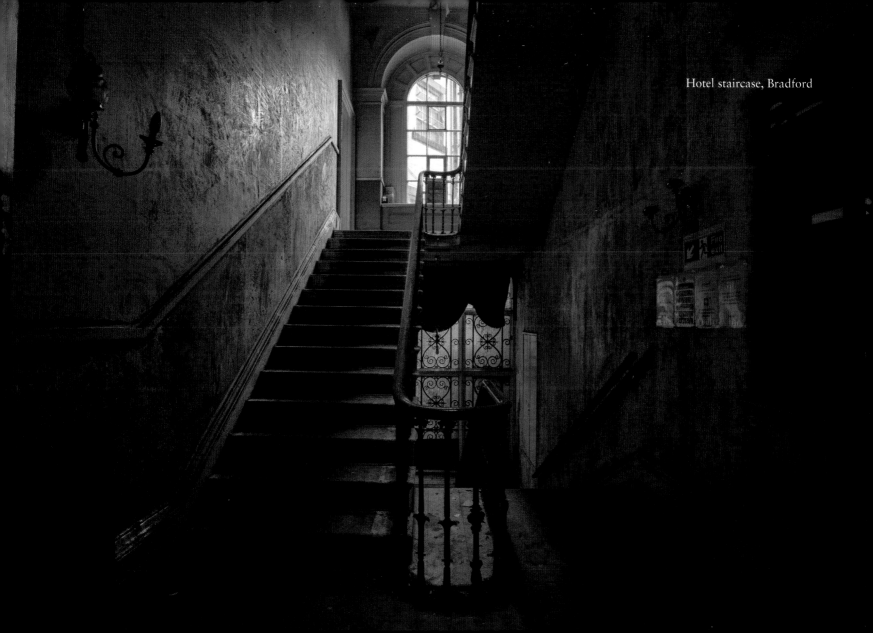

Hotel staircase, Bradford

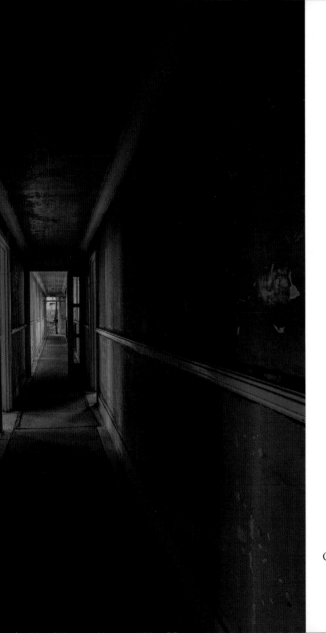

Corridor in the hotel

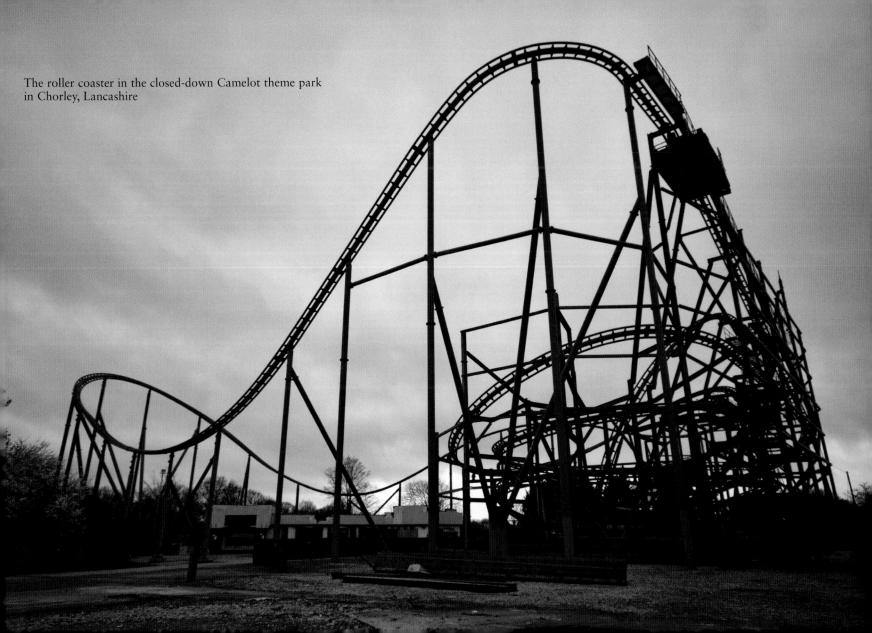

The roller coaster in the closed-down Camelot theme park
in Chorley, Lancashire

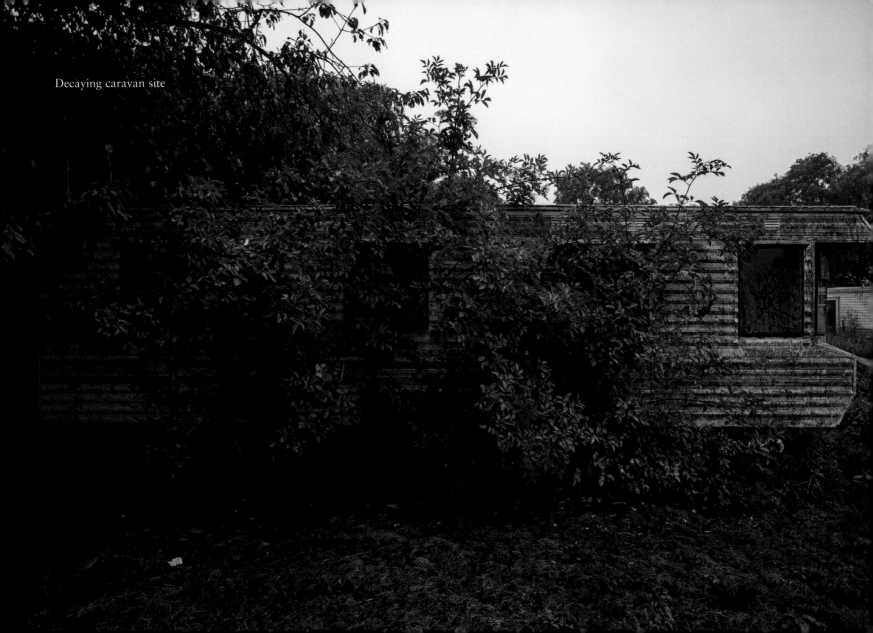

Decaying caravan site

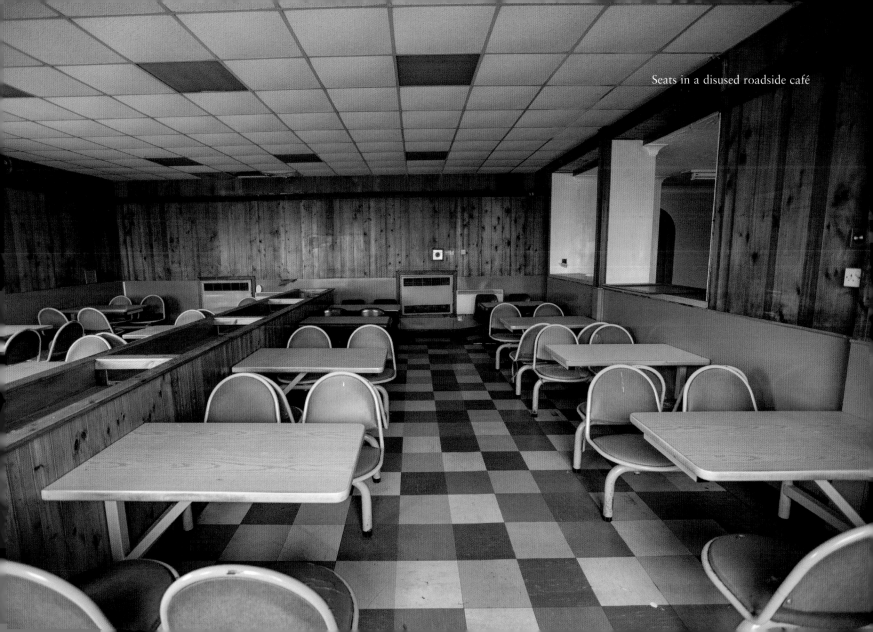

Seats in a disused roadside café

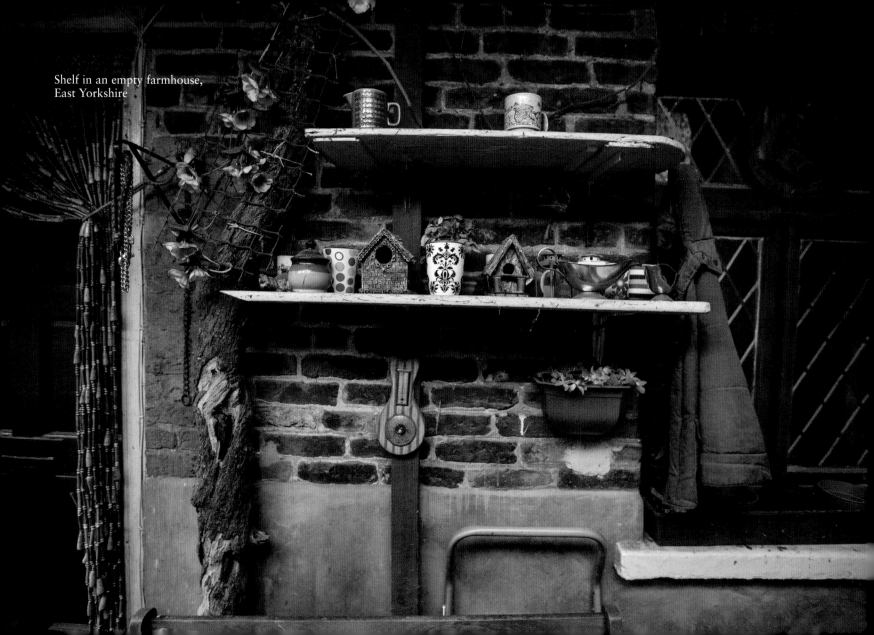

Shelf in an empty farmhouse,
East Yorkshire

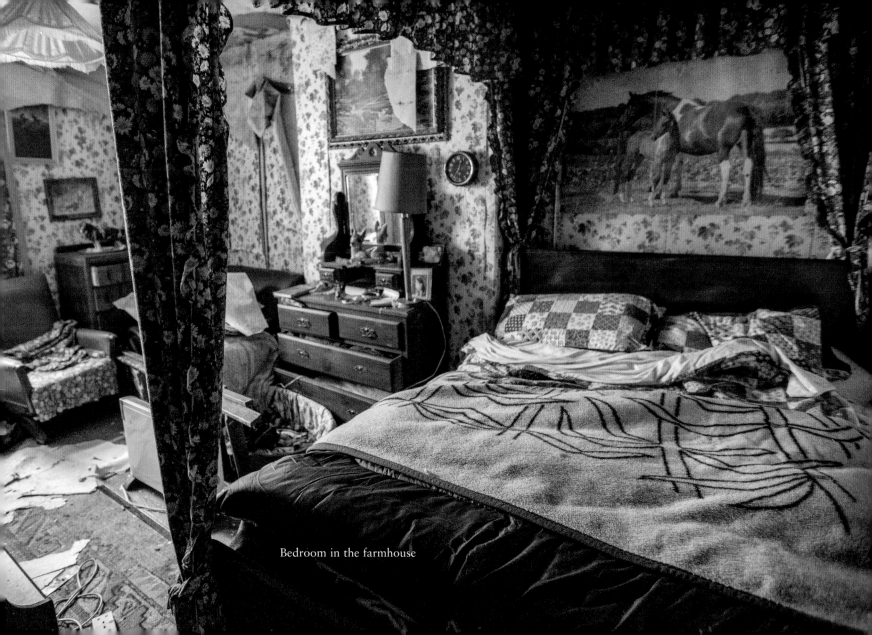

Bedroom in the farmhouse

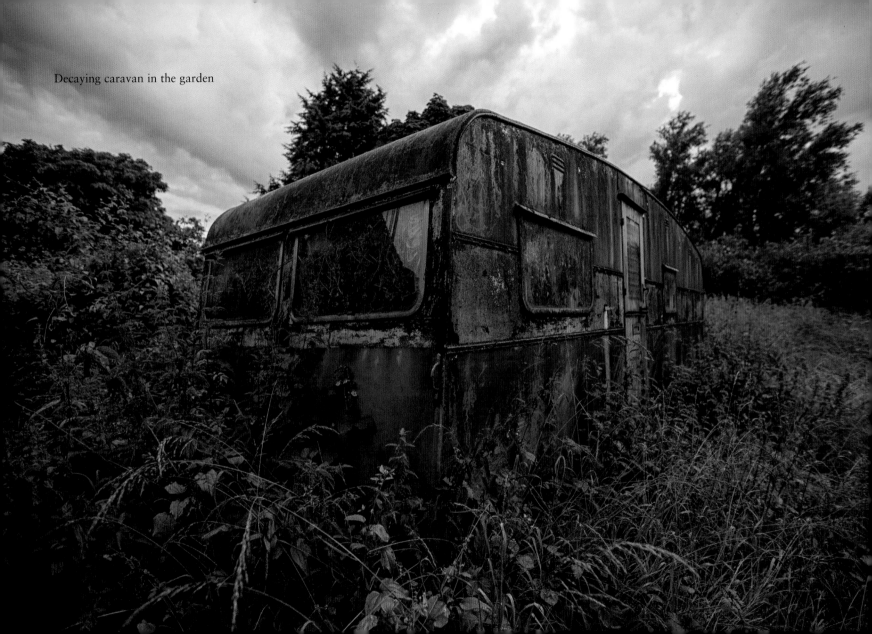

Decaying caravan in the garden

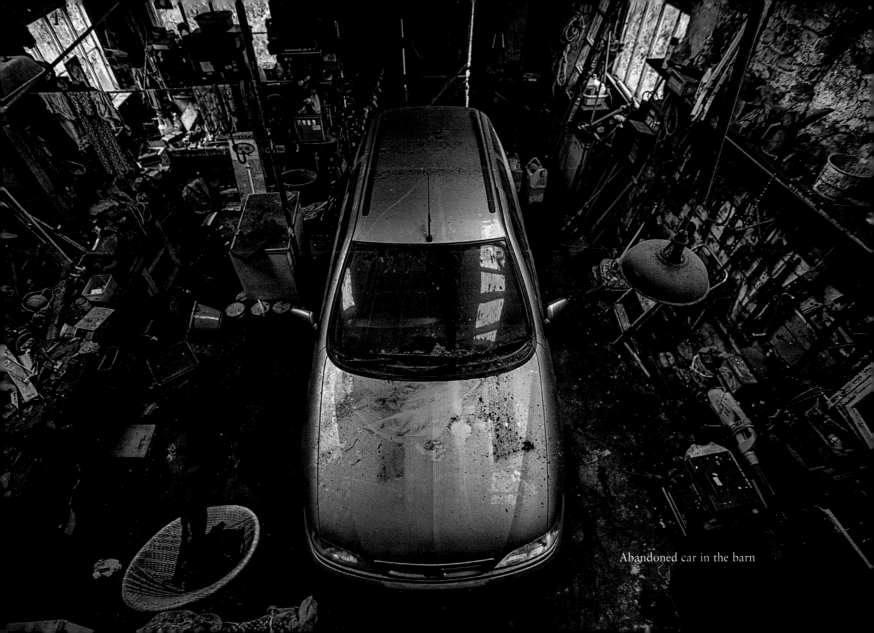

Abandoned car in the barn

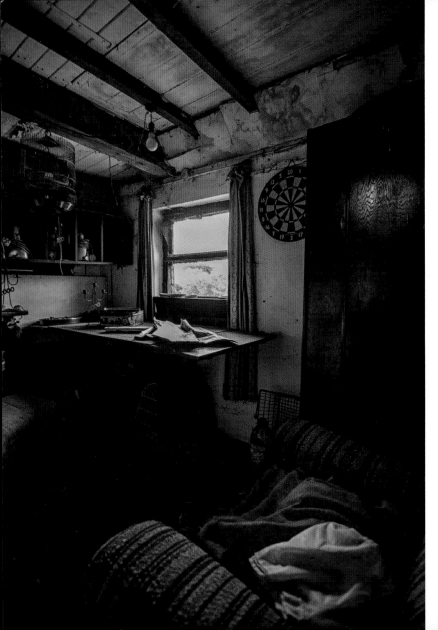

Left: The farmhouse workshop

Below: Another corner of the workshop

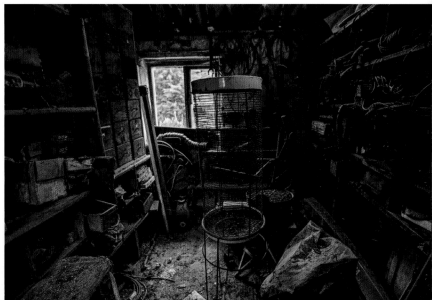

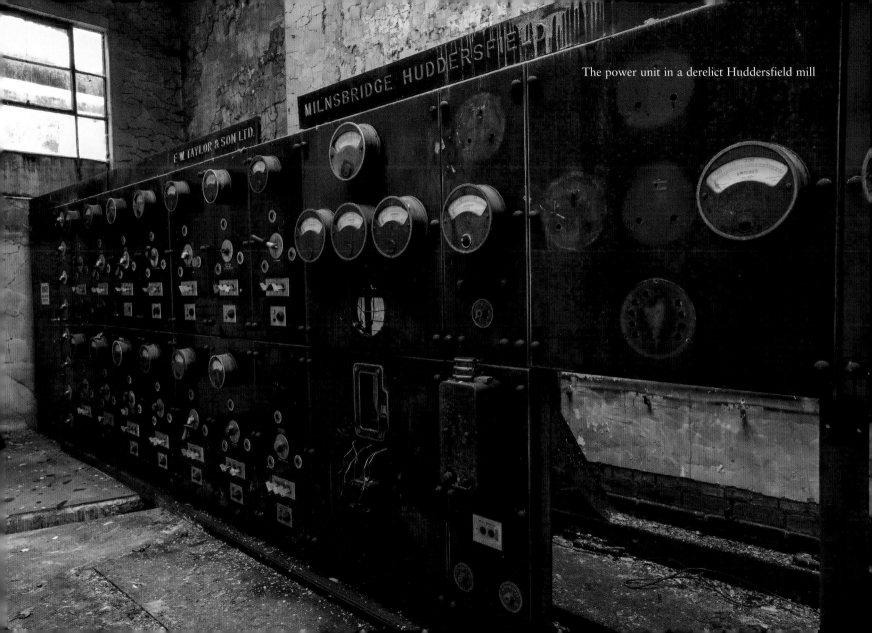

The power unit in a derelict Huddersfield mill

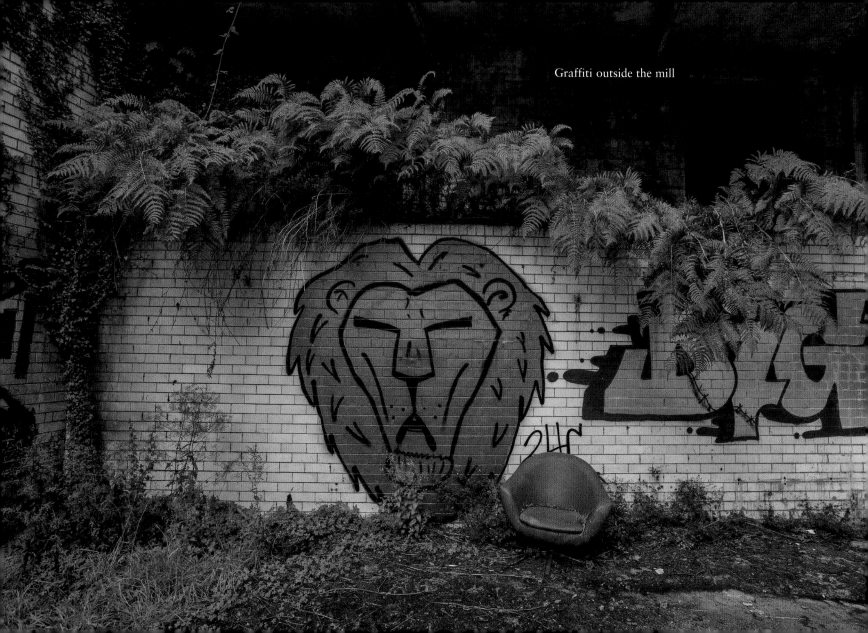

Graffiti outside the mill

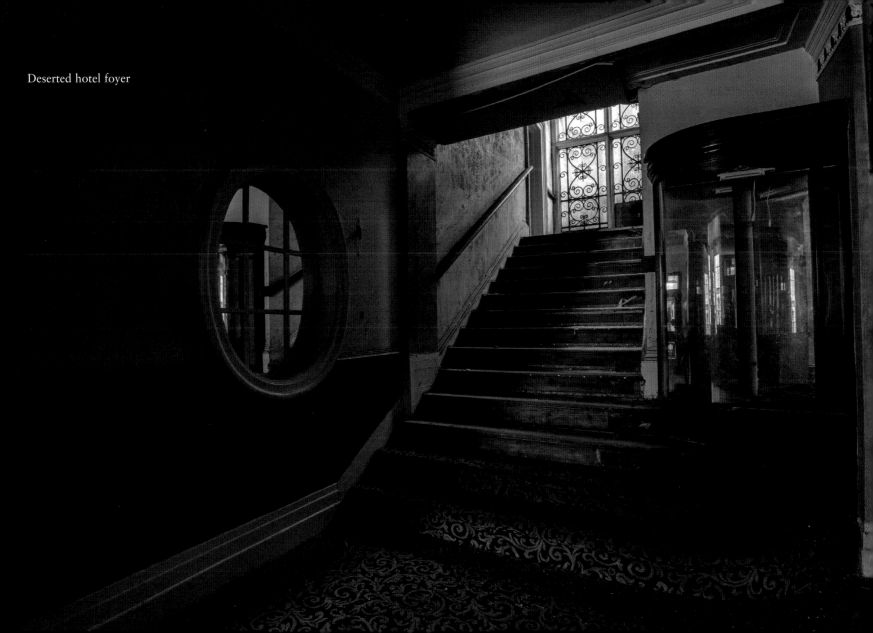
Deserted hotel foyer

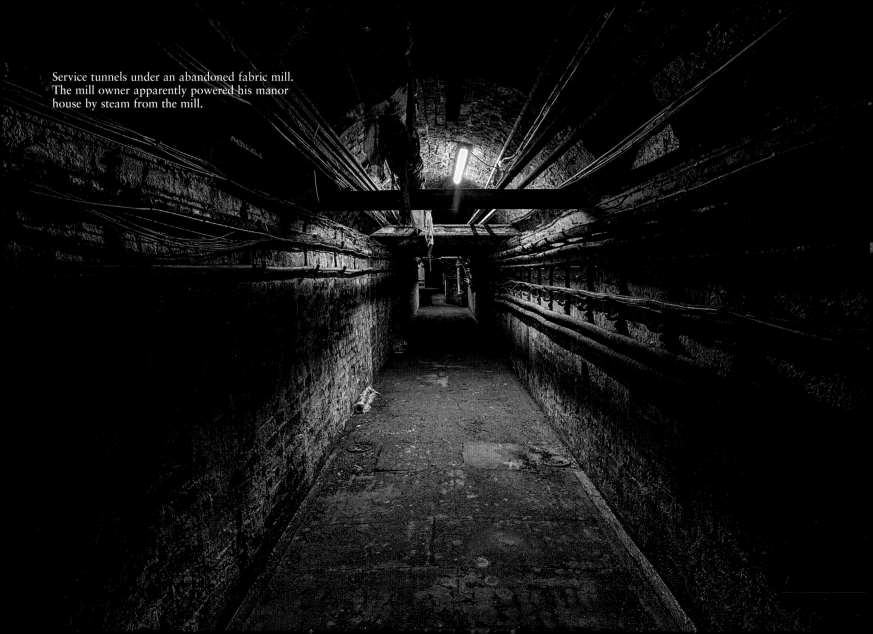

Service tunnels under an abandoned fabric mill.
The mill owner apparently powered his manor
house by steam from the mill.

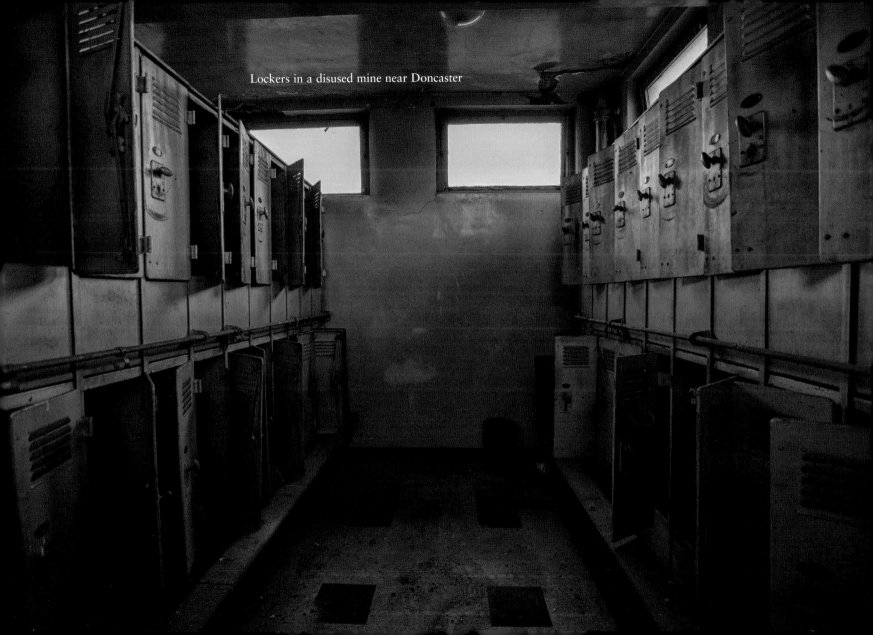

Lockers in a disused mine near Doncaster

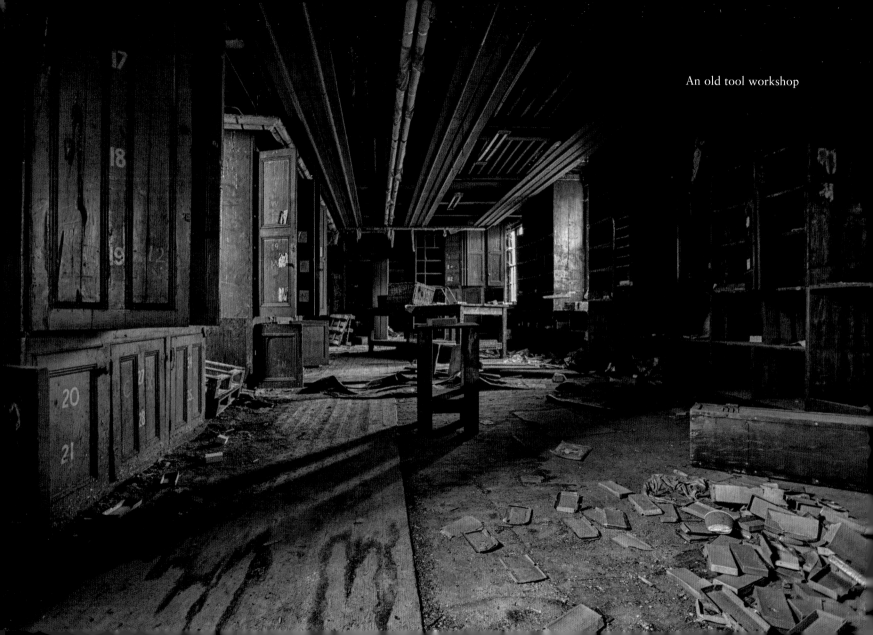

An old tool workshop

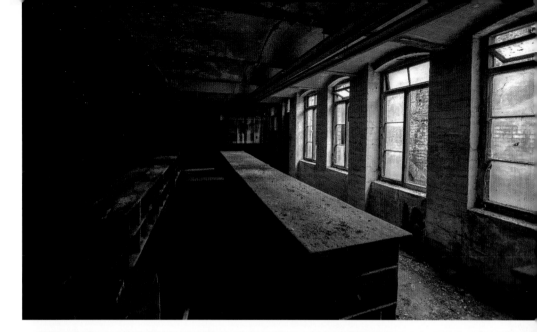

Workbench in the tool shop

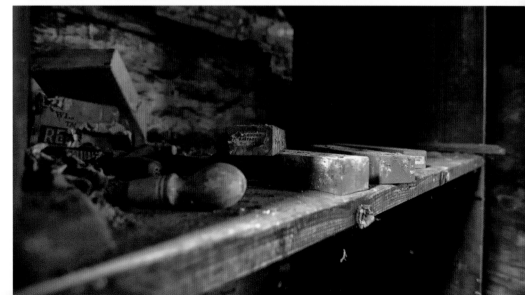

Close-up of tools in toolmaker factory

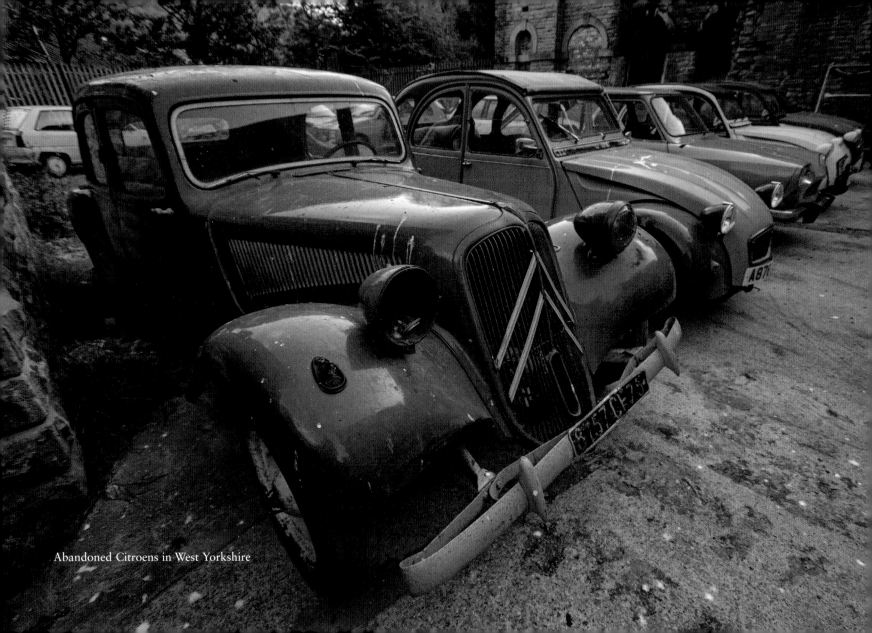

Abandoned Citroens in West Yorkshire